The Campus History Series

TOWSON UNIVERSITY

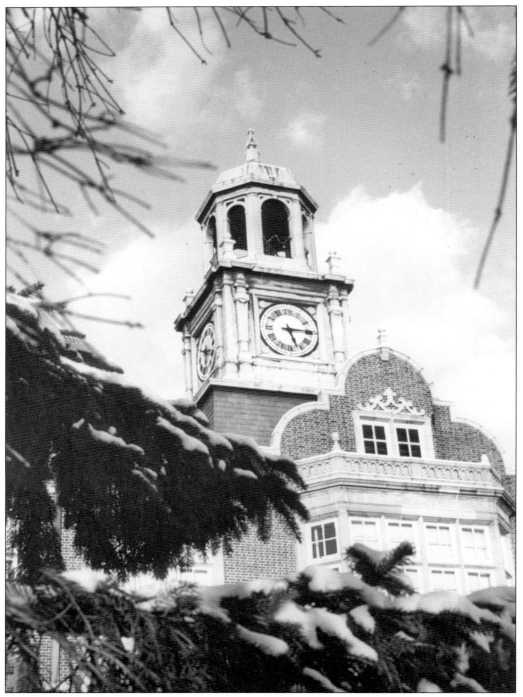

STEPHENS HALL. Stephens Hall is a well-known Maryland landmark.

Cover Image: In front of Stephens Hall, students from the class of 1941 relax around the sundial, which was a gift from the class of 1931.

The Campus History Series

TOWSON UNIVERSITY

DEAN ESSLINGER WITH LORI ARMSTRONG, ANGIE BRICKHOUSE,
NANCY GONCE, AND KAREN LOWMAN

ARCADIA

Published by Arcadia Publishing
Charleston SC, Chicago IL, Portsmouth NH, San Francisco CA

Printed in Great Britain

Library of Congress Catalog Card Number: 2005928192

For all general information contact Arcadia Publishing at:
Telephone 843-853-2070
Fax 843-853-0044
E-mail sales@arcadiapublishing.com
For customer service and orders:
Toll-Free 1-888-313-2665

Visit us on the internet at http://www.arcadiapublishing.com

CONTENTS

INTRODUCTION AND ACKNOWLEDGMENTS

This book offers a small visual sample of the many people—faculty, students, and staff—who make up the 140-year history of Towson University. No single book can capture all of the achievements nor tell all of the personal stories that fill the rich historical environment of one of Maryland's leading educational institutions. Nevertheless, readers might find faces or memories that help to recall their collegiate experiences, or learn for the first time about the people and events that created Towson University.

In the spring and summer of 2005, a small group of individuals were asked by the Alumni Association to put together this photographic history. Dr. Dean Esslinger, professor of history and associate vice president of International Programs, created the structure of the book, worked with the committee to select the photographs, and wrote the captions. Nancy Gonce, university archivist, was the key individual who shared her vast knowledge of the university's past, found fascinating images from the historical files, and did exceptional work in preparing the photos for the publication. Lori Armstrong, associate vice president of Alumni Relations; Angie Brickhouse, alumni volunteer coordinator; and Karen Lowman, Alumni Association board representative; helped formulate the concept of the book, reviewed the drafts of each chapter, and offered constructive suggestions. Lauren Rudnick, administrative assistant for International Programs, provided valuable support in preparing the final manuscript for publication. Thanks also go to Kanji Takeno and Sofia Silva of Photographic Services; to Dan O'Connell from Sports Information; to Binnie Braunstein, friend of the university; to the staff of Design and Publications and the staff of University Relations; and to the staff of the Center for Instructional Advancement and Technology. And finally a special thanks to all those students who attended Towson during the last 140 years and to the men and women who helped them learn.

GREETINGS FROM THE UNIVERSITY PRESIDENT

When the Maryland State Normal School opened in 1866, the Civil War was just over. Oil lamps and candles lit most homes, and ice, cut from Northern rivers, made its way to Baltimore on barges. Today, 140 years later, it seems almost superfluous to point out that those who studied in the 19th century would marvel at the fast food, instant messaging, and other technologies that define the lives of students who attend what is now known as Towson University.

So there is a strange and glorious tenor in recording the routine memories of the many generations who have attended Towson. From the now-forgotten traditions of May Day and the Olde English Dinner to latter-day construction projects, athletic championships, international students, and regional partnerships, Towson University treasures its past, its present, and its future. The incredible beauty of this campus, the creative energy of scholarship, and the personal voyages of our students have left indelible imprints through the years.

This book, *Towson University*, traces the college life, the campus footprint, and the town that surrounds this vast and intricate institution. Yet among the interesting archival photos and footnotes from the past, there remains the currency of teaching, research, and outstanding public service that make up this great modern metropolitan university of today.

At Towson, we constantly dedicate ourselves to developing a better institution, accepting no substitute for quality and no excuse for mediocrity. Our professors challenge students every day to become better. The university recognizes and realizes its essential and overriding goal of transforming lives through knowledge.

This book maps Towson's past, while today we continue to map Towson's future.

—Robert L. Caret
President
Towson University

GREETINGS FROM THE ALUMNI ASSOCIATION PRESIDENT

As I reflect on Towson University's 140th anniversary, I am in awe of the significant impact that this institution has had on my life. What some people may think of as bricks and mortar laid the foundation for a family that arrived from Denmark in 1951.

My father was Towson University's Physical Plant superintendent from 1958 to 1966. A strong Nordic man, he ensured that the students were well provided for through the care of the facilities. I recall residing on campus with my family in a quaint house that was demolished in 1963 to make way for Towsontowne Boulevard. When it was time to pursue a higher education experience, there was no other choice but Towson State College. It was my home. Towson University is where I learned to use a Geiger counter to monitor radiation in my civil defense class taught by my dad. Towson University is where I learned to become a teacher—a profession that is so dear to my heart—and Towson University is where I learned so much about life. And that beat goes on. . . . Towson University is where my daughter, Kirsten, was awarded her degree in 2002.

As president of the Towson University Alumni Association, my heart swells with gratitude and pride as I meander through the memories of my life and how thankful I am to this community for its indescribable gift. I thank my family—Marty, Tony, Matthew, and Kirsten—for their ongoing support of my volunteer activities and the sacrifices they have made so that I could be with my beloved TU.

I will be forever proud that my board members and I were able to play a small part in the mark of history that this publication will hold for future Towson University alumni, students, faculty, staff, and friends. I truly thank the author, Dean Esslinger, and his volunteer committee members, Lori Armstrong, Angie Brickhouse, Nancy Gonce, and Karen Lowman, for without their tireless efforts and occasional leap of frustration, this publication would not have been possible. Enjoy!

Warm Regards,

—Lone Azola '68
President
Towson University Alumni Association

One

MARYLAND STATE NORMAL SCHOOL *1866–1935*

THE BEGINNING. In 1865, the General Assembly passed an act calling for a "uniform system of public schools for the State of Maryland." The formalization of public education required the creation of a teachers' training school, known as a normal school.

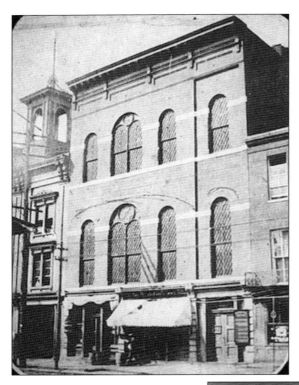

RED MEN'S HALL. The Maryland State Normal School (MSNS) opened on January 15, 1866, in Red Men's Hall at 24 North Paca Street in Baltimore. The 11 students who enrolled the first day were taught by four faculty members: "The principal and teachers of drawing, music, and calisthenics." Classes were held in one large hall measuring 70 by 28 feet. (Source: Seventy-five Years of Teacher Education.)

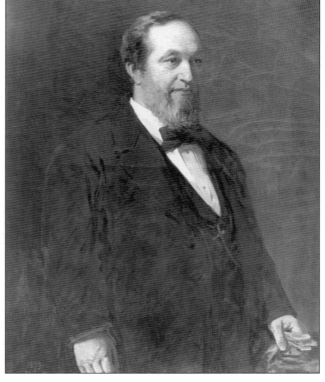

PRINCIPAL NEWELL. Prof. McFadden Alexander Newell, the first and longest-serving principal (1866–1890), was the major force in the MSNS's early development. A graduate of Trinity College, Dublin, he was a strong advocate for a professional curriculum, in-service training for teachers, higher professional standards, and higher salaries. In 1871, he opened two model schools, one for boys and one for girls, so students of the normal school could practice teaching.

FIRST GRADUATES. At the first commencement on June 8, 1866, there were 16 graduates: 4 grammar school teachers and 12 primary school teachers.

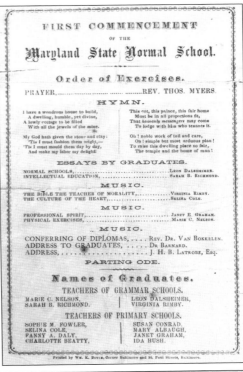

FIRST COMMENCEMENT
OF THE
Maryland State Normal School.

Order of Exercises.

PRAYER,...REV. THOS. MYERS.

HYMN.

I have a wondrous house to build, This cot, this palace, this fair home
A dwelling, humble, yet divine, Must be in all proportions fit,
A lowly cottage to be filled That *heavenly messengers* may come
With all the jewels of the mine. To lodge with him who tenants it.

My God hath given the stone and clay; Oh! noble work of toil and care,
'Tis I must fashion them aright,— Oh! simple but most arduous plan!
'Tis I must mould them day by day, To raise this dwelling place so fair,
And make my labor my delight. The temple and the house of man!

ESSAYS BY GRADUATES.

NORMAL SCHOOLS,...........................LEON DALSHEIMER.
INTELLECTUAL EDUCATION,...................SARAH B. RICHMOND.

MUSIC.

THE BIBLE THE TEACHER OF MORALITY,...........VIRGINIA RIMBY.
THE CULTURE OF THE HEART,....................SELINA COLE.

MUSIC.

PROFESSIONAL SPIRIT,.........................JANET E. GRAHAM.
PHYSICAL EXERCISES,..........................MARIE C. NELSON.

MUSIC.

CONFERRING OF DIPLOMAS,.... REV. DR. VAN BOKKELEN.
ADDRESS TO GRADUATES,.....DR BARNARD.
ADDRESS,.....................J. H. B. LATROBE, Esq.

PARTING ODE.

Names of Graduates.

TEACHERS OF GRAMMAR SCHOOLS.

MARIE C. NELSON. LEON DALSHEIMER,
SARAH B. RICHMOND. VIRGINIA RIMBY.

TEACHERS OF PRIMARY SCHOOLS.

SOPHIE M. FOWLER, SUSAN CONRAD.
SELINA COLE, MARY ALBAUGH,
FANNY A. DALY, JANET GRAHAM,
CHARLOTTE BEATTY, IDA HUSH.

Printed by WM. K. BOYLE, Corner Baltimore and St. Paul Streets, Baltimore.

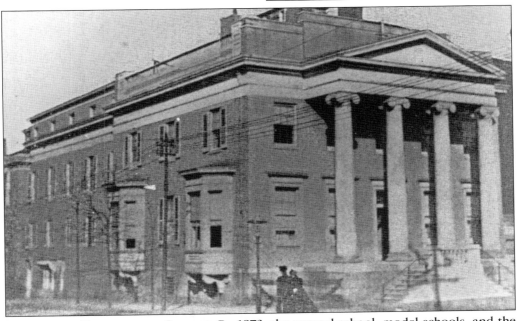

ATHENEUM AT FRANKLIN AND CHARLES. By 1873, the normal school, model schools, and the State Superintendent of Education offices moved to better quarters at what later was known as the Atheneum Club at Franklin and Charles Streets. Enrollment had grown to 162 students taught by 9 faculty members. Students paid $20 a month for meals and $75 per year tuition, if they did not sign the pledge to teach.

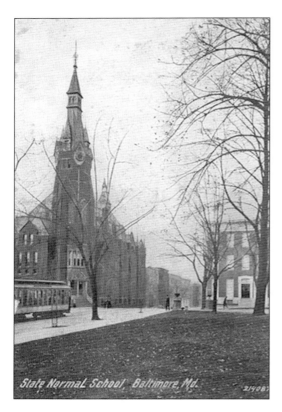

State Normal School, Baltimore, Md.

CARROLLTON BUILDING. On February 29, 1876, classes began at the unfinished new building at Carrollton and Lafayette Avenues. Costing $100,000, the new facility had 10 classrooms, a reception room, the State Board of Education office, a principal's residence, a library, and cloak and "retiring" rooms. It was none too soon for a new building, since the ceiling had fallen in one of the classrooms at the Atheneum.

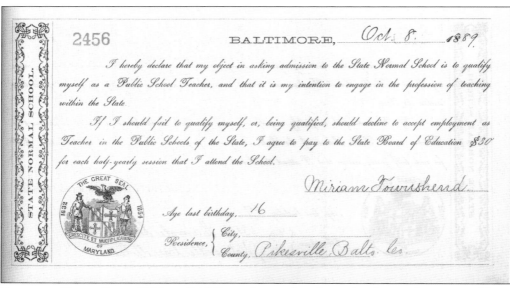

2456 BALTIMORE, Oct. 8. 1889

STATE NORMAL SCHOOL.

I hereby declare that my object in asking admission to the State Normal School is to qualify myself as a Public School Teacher, and that it is my intention to engage in the profession of teaching within the State.

If I should fail to qualify myself, or, being qualified, should decline to accept employment as Teacher in the Public Schools of the State, I agree to pay to the State Board of Education $30 for each half-yearly session that I attend the School.

Miriam Townshend

Age last birthday, 16

Residence, { City, County, Pikesville Balto. Co.

PLEDGE TO TEACH. From 1866 until 1972, students who planned to be teachers were able to attend the school without paying tuition. Students signed the "pledge to teach," a two-year commitment to teach in Maryland's public schools.

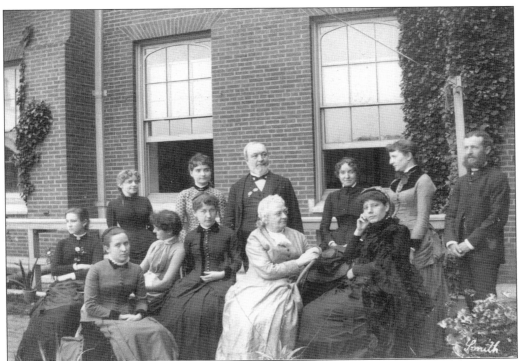

MSNS FACULTY AND STAFF. By the 1886–1887 academic school year, faculty taught a curriculum of English language and literature, "algebra, bookkeeping, arithmetic, geometry, music, Latin, theory of teaching, and observation and practice of teaching." (Source: Seventy-five Years of Teacher Education.)

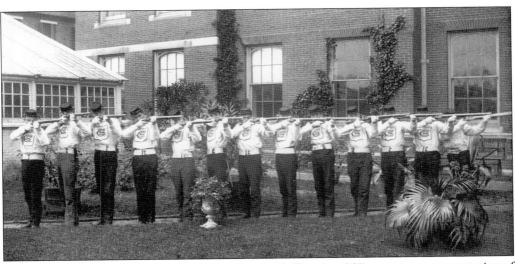

MEN'S RIFLE TEAM. The men's rifle team, shown drilling in 1887, was not representative of the student body, since most students who enrolled were young women. During the first decades of the school's history, the proportion of male students never rose above 17 percent. The minimum age for admission to the school was 16.

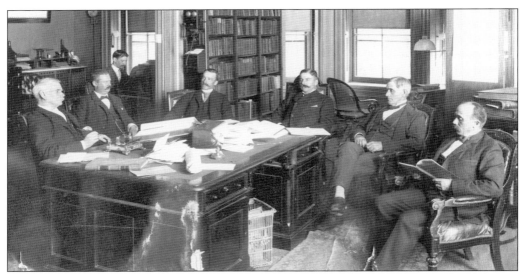

PRINCIPAL AND SCHOOL BOARD. Principal E. Barrett Prettyman (1890–1905), shown (far left) with the school's board, was one of the leaders who expanded the school's development. The school was organized into five departments: Pedagogy, English, History, Science, and Mathematics. The MSNS was already educating more than one out of every six teachers in the state. In 1898, the Maryland General Assembly nearly doubled the annual budget from $10,800 to $20,000.

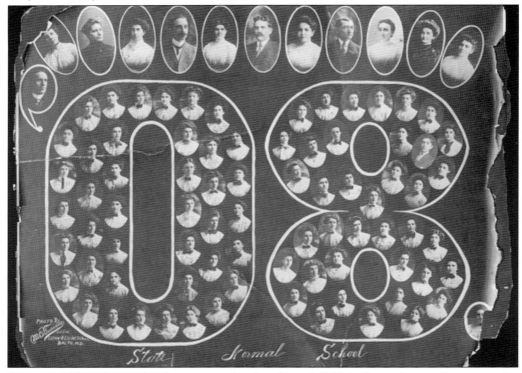

CLASS OF 1908. The graduation picture for the class of 1908 is shown here using a popular style of arranging the graduate pictures within an image of the class year.

ARITHMETIC

1. A hunter standing 39 paces of 3 feet from a pole 6 feet in diameter shot a hawk from its top. How far did the ball move to reach the hawk, provided it started five feet above the ground?

BOOK KEEPING

1. Name and describe the three principle books used in Book Keeping.
2. Into what classes may all business transactions be resolved? Give the rules for each class.

CHEMISTRY

1. Give examples of monads, dyads, triads and tetrads.
2. Describe some of the principal methods of cooking meat, and explain the chemical changes that take place.

DRAWING

1. What is perspective?
2. How do you measure heights?

GEOGRAPHY

1. Explain the precession of the equinoxes.
2. Name the counties and county towns on the Western Shore of Maryland.

NATURAL PHILOSOPHY

1. Write brief notes on: The law of incidence and reflection.

PARSING

1. Parse all the words in the following sentence:
 If to do were as easy as to know what were good to do, chapels had been churches, and poor men's cottages, princes' palaces.

PHYSIOLOGY

1. Describe the aponeurosis and state the advantages and disadvantages of its flexibility.
2. What injurious effects are liable to be produced upon the internal organs by exposure to wet or cold?

THEORY OF TEACHING

1. What should be the great aim of a teacher?
2. Write brief notes on the difference between emulation and rivalry as a motive power.

EXAMINATION QUESTIONS. Although students were required to pass standard examinations, by the early 20th century, the faculty made strong efforts to offer individual attention and individualized programs to the students. A four-year curriculum was now available, and the library had grown to almost 5,000 volumes.

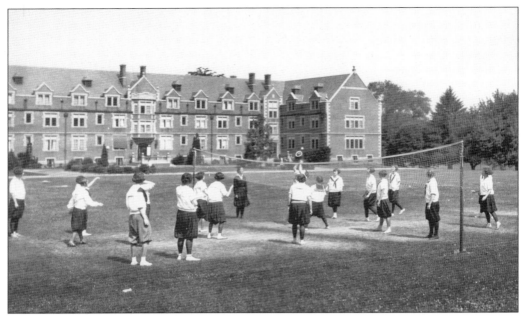

PHYSICAL EDUCATION. Although there was a firm belief from the beginning that physical health promoted academic success, little was provided for physical education. Not until 1901 were any organized games or sports introduced into the school. Shown here are female students playing volleyball in front of Newell Hall in the 1920s.

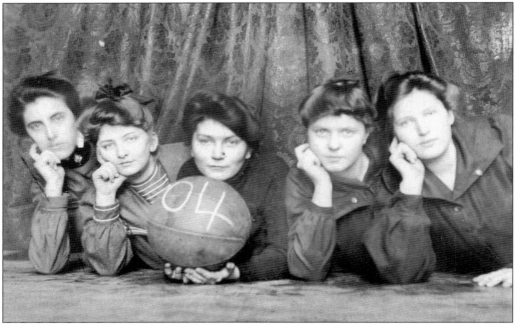

WOMEN'S BASKETBALL, 1904. Girls' basketball, at least at the intramural level, began at the same time boys' teams were established. Shown here is the 1904 women's basketball team. Team players from left to right are Lillian Compton, Mary Grim, Sadie Booze, Roxanna Steele, and Ethel Speake.

**FIRST FEMALE PRINCIPAL,
1909–1917.** Sarah Richmond, a
member of the first graduating
class in 1866, returned to
MSNS as a mathematics teacher.
For 55 years, she served as
teacher, vice principal, and
eventually the first female
principal. After stepping
down as principal in 1917,
she became the first dean of
women. She raised entrance
requirements, expanded the
curriculum, created new
departments, and was the main
advocate for moving the school
to Towson.

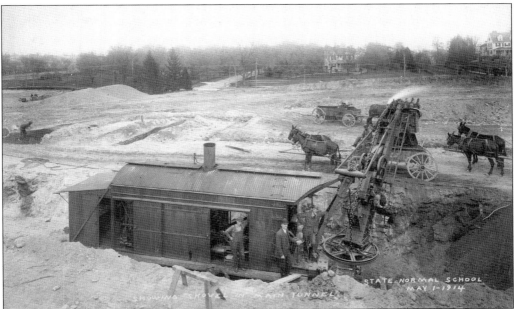

THE NEW TOWSON CAMPUS. Based on Richmond's campaign, the General Assembly passed a
$600,000 bond issue in April 1912, making MSNS the largest building initiative in the state.
Near the trolley and railroad lines in Towson, they built Stephens Hall, the Newell Hall
dormitory, and the power plant. A home already on the grounds, Glen Esk, served as the
principal's residence. The new campus opened in September 1915.

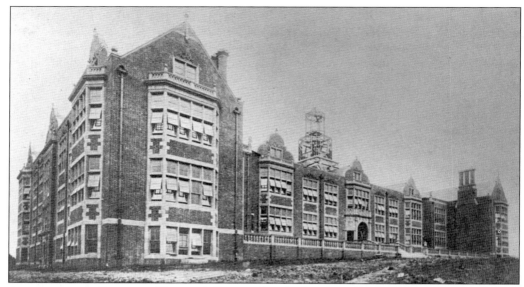

ADMINISTRATION BUILDING. The partially completed administration building rises high on the hillside. It was the hub of campus activities until 1972 when a new administration building opened. In 1957, the building was renamed Stephens Hall in honor of M. Bates Stephens, state superintendent of education from 1900 to 1920.

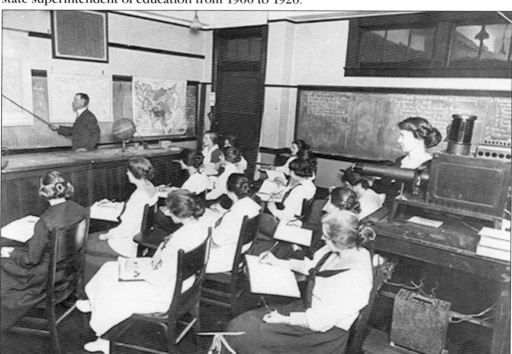

GEOGRAPHY CLASS. This geography class at the new campus in 1918 shows the appeal of a well-equipped classroom, but it fails to show the troubles that the MSNS was facing. The move out of Baltimore City, combined with the impact of World War I, dealt a blow to enrollment. From a high of 363, the school's enrollment dropped to 131 just five years later.

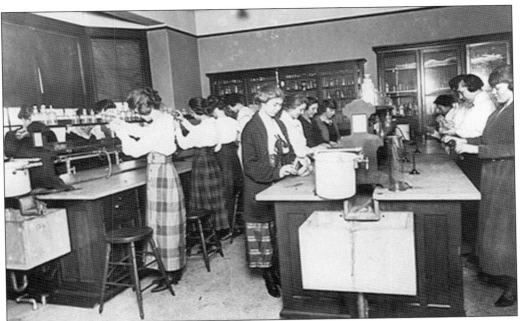

CHEMISTRY CLASS. This chemistry class in 1918 illustrates the growth of the curriculum by the second decade of the 20th century with the expansion of laboratory sciences and a broader range of subjects being taught.

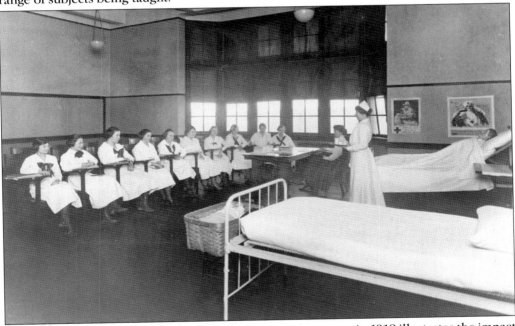

RED CROSS COURSE. This Red Cross class at the Towson campus in 1918 illustrates the impact of World War I on the college. Students joined community members to sew and roll bandages for Red Cross units, new courses were created to study the wartime economy, and special courses in first aid and nursing were introduced. The school's facilities were offered as a community center for groups from Towson and Baltimore County.

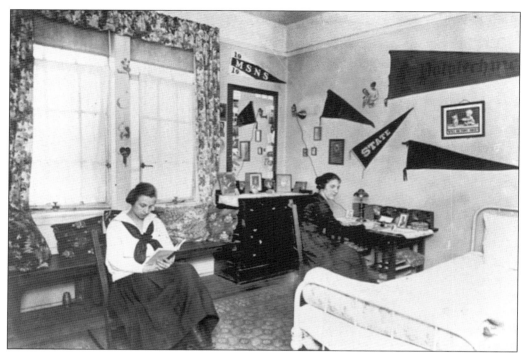

DORM LIFE. One effort to counter the decline in enrollment that accompanied World War I was the opening of the first summer session at Towson in 1918. The main purpose was to give teachers an opportunity to take summer classes to achieve the standard required by the state law, but many of these mature teachers found dormitory life too restrictive.

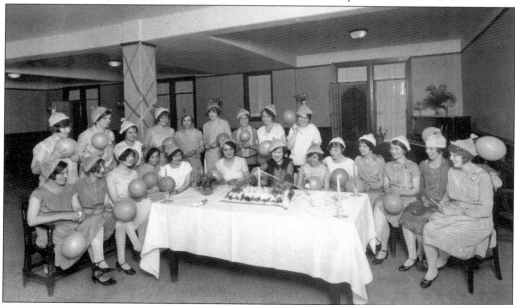

BIRTHDAY PARTY. Having a dormitory for female students enabled the women to enjoy a closer relationship with each other. Birthday parties were just one of many social events for campus residents.

PESTALOZZI LITERARY SOCIETY. Faculty and students organized two literary societies in October 1869 to create a wholesome rivalry among the students and to engage them in literary and social events. At the first school assembly of the year, each new student and faculty member drew a slip from a receptacle. The slips were marked either Normal or Pestalozzi, making the individual either a "Norm" or a "Pest" for the rest of his or her life.

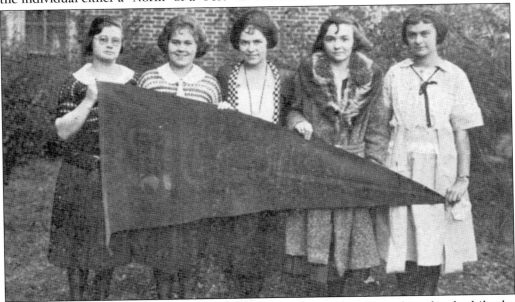

NORMAL LITERARY SOCIETY. The Normal Society took its name from the school while the Pestalozzi Society was named after the Swiss 18th-century educator Johann Heinrich Pestalozzi. Each society met regularly and planned a variety of debates, lectures, and dramatic, literary, and musical programs. Literary journals were prepared to showcase the poetry and other writing of the members. Social life centered on the literary societies, where strong loyalties and rivalries developed. By 1927, the literary societies were discontinued.

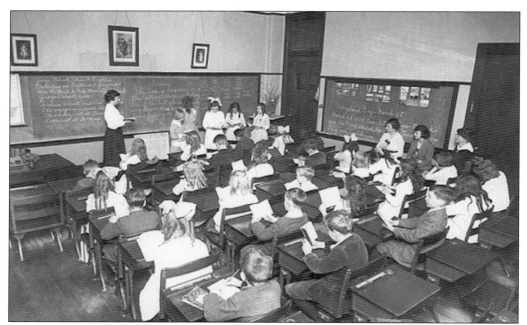

STUDENT TEACHING. Student or practical teaching took place from the beginning in 1866 at what was first called the Model School then later, by 1920, the Campus Elementary School. By 1922, students specialized in either primary, upper grades, or rural (one-room school) teaching.

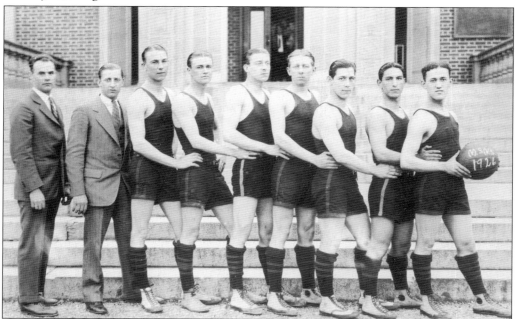

MEN'S BASKETBALL TEAM. By the 1920s, when larger numbers of men enrolled in MSNS, the role of athletics increased. Dr. William Burdick directed the athletic program, and the school established a Department of Hygiene and Physical Education. The men's basketball team of 1925–1926, consisting of only seven players, was coached by Harold Callowhill (left).

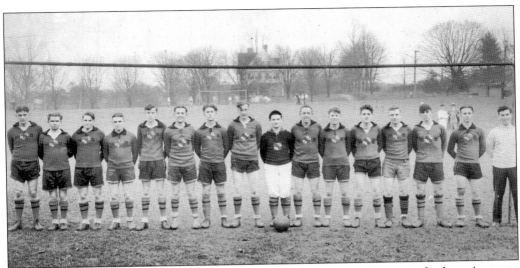

MEN'S SOCCER. Dr. Donald Minnegan, far right in this 1928 team photo, coached men's soccer and served also as athletic director from 1929 to 1971. Under his direction, the athletic program became an important part of the campus life. To meet the expense of providing sports equipment and facilities for all students, an athletic fee was charged to all who enrolled.

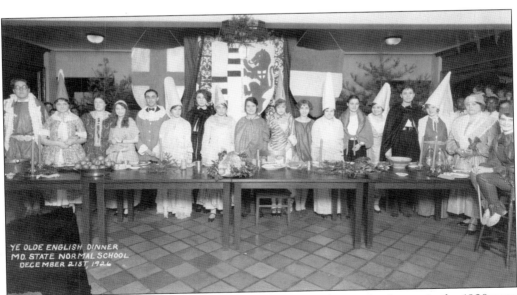

YE OLDE ENGLISH DINNER. One of the best-loved school traditions that began in the 1920s was the Ye Olde English Dinner. Begun as an event for the dormitory students before the Christmas holidays, it was a time for dressing up as fair maids or jesters, for colorful processions, and for feasting at the "groaning board."

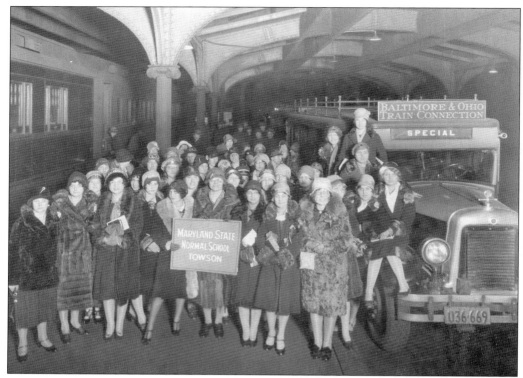

THE NEW YORK TRIP. Another tradition was the overnight train trip to New York City by the graduating senior class.

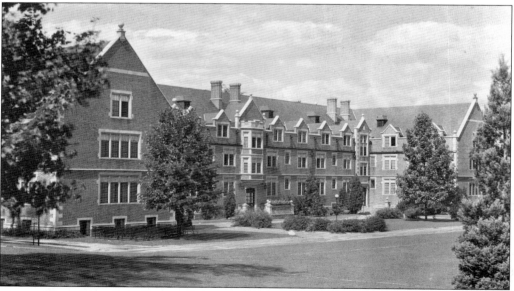

NEWELL HALL. Newell Hall, one of the original buildings constructed on the new Towson campus in 1914, provided the living space for the students. Built in the unique Jacobean architectural style, Newell, along with Stephens Hall, became one of the symbols of the Normal School on York Road.

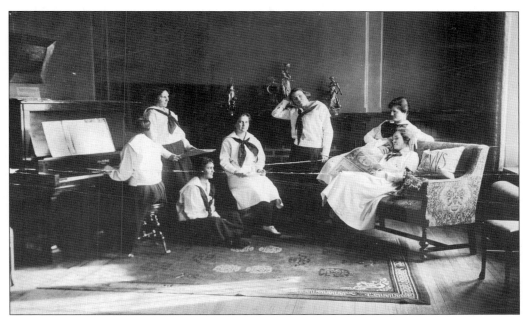

NEWELL HALL PARLOR. Besides study space and dormitories for sleeping, Newell Hall had a parlor that was a gathering place for students in their leisure hours.

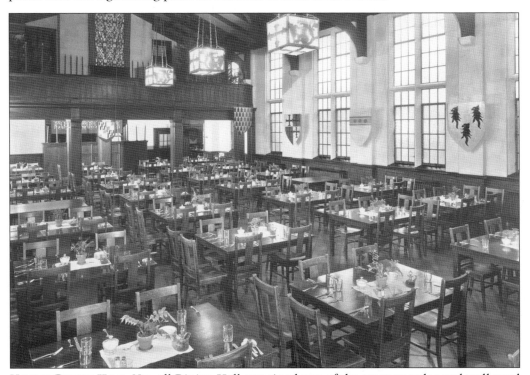

NEWELL DINING HALL. Newell Dining Hall remained one of the most popular and well-used eating-places for students, faculty, and staff into the 21st century, with periodic remodeling to meet current standards.

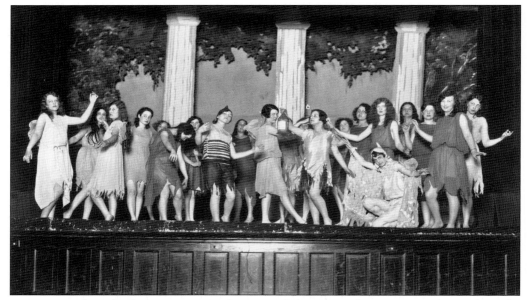

MUMMERS. When the literary societies began to fade in popularity among the students by the late 1920s, they were replaced by a dramatic club called the Mummers. Focused at first on one-act plays, the Mummers expanded to three-act plays by the 1930s and established a strong tradition for drama that would eventually lead to the creation of Towson's theatre department in the 1960s.

STUDENT ORGANIZATIONS. Student life in the years between the world wars often centered on clubs and organizations. The Junior Class Officers of 1928, shown here, are typical of the students who participated in craft and music clubs, the international relations club, the YMCA, the National History Group, sororities and fraternities, honor societies, Girl Scouts and Camp Fire Girls, and student government organizations.

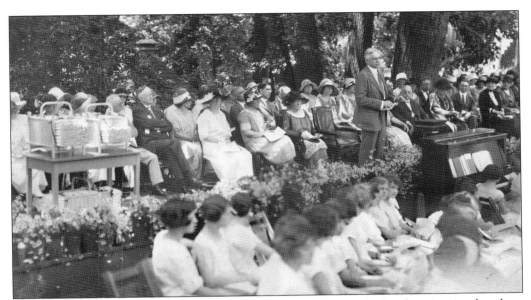

COMMENCEMENT CEREMONIES. From its beginning, the normal school maintained a close relationship with the State of Maryland because of its role in producing teachers. The head of the school served as superintendent of state schools in the 19th century, and public officials often acknowledged the value of the school's graduates. At this outdoor graduation ceremony in the 1920s, Gov. Albert C. Ritchie presents diplomas to the graduating students.

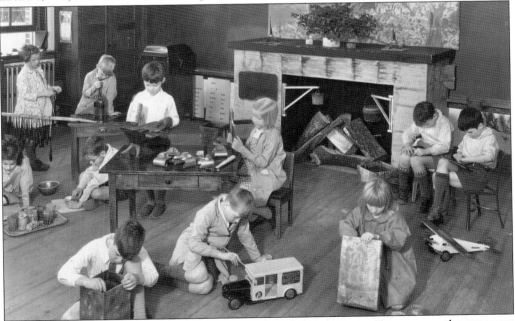

CAMPUS ELEMENTARY SCHOOL. A strength of the education program at Towson was the presence of the campus elementary school, later named after Lida Lee Tall. Faculty could use the school to experiment with ways to improve teaching, and future teachers could gain first-hand experience in the classroom. Students who attended the elementary school benefited from the high quality of teaching, whether in traditional subjects or in less structured settings.

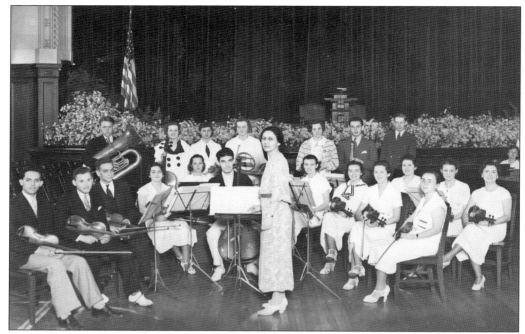

CAMPUS ORCHESTRA. Although an orchestra existed briefly in 1913–1914, the current orchestra dates from January 1922. An article in the student newspaper, *Oriole*, remarked, "We had a drummer, but no drums, a cornetist with a worn out cornet, two or three violins, and an accompanist or two."

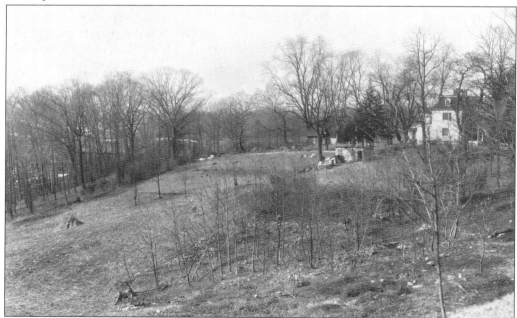

CAMPUS GROUNDS. Prior to development of the Glen in the 1930s, the MSNS grounds in Towson consisted of rolling wooded hills. The cottage, shown here, stands on the future site of Smith Hall, the science building, and on the edge of the Glen.

AL RUBELING. Al Rubeling, class of 1932, was one of the normal school's most famous graduates of the period between the world wars. Elected to Towson's Athletic Hall of Fame for his achievements on the baseball, basketball, and soccer teams, he went on to play major-league baseball in the 1940s for the Philadelphia Athletics and the Pittsburgh Pirates.

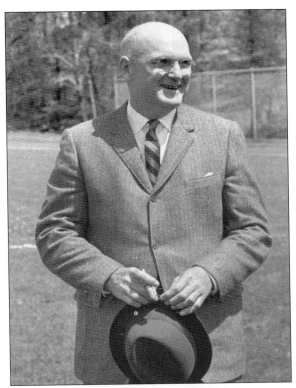

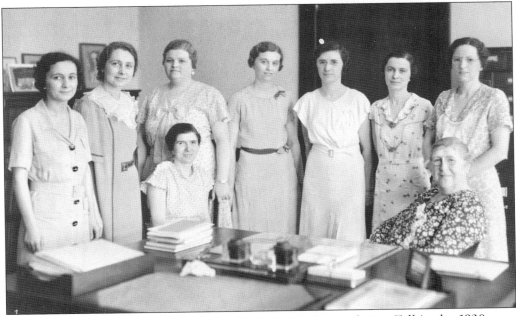

ADMINISTRATION. The all-female administrative staff of Dr. Lida Lee Tall in the 1930s was a contrast to the largely male staff and board of 1866. Behind Dr. Tall (seated right) and Rebecca Tansil (seated left), the registrar and business manager, are the staffers responsible for the school's business and academic services.

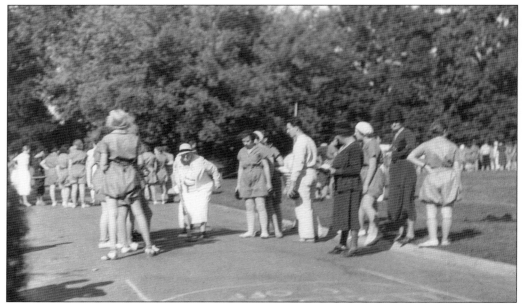

LIDA LEE TALL AT PLAY. Dr. Tall may have been a major force in the development of the Normal School, but she also appreciated the value of recreation and celebration. She's poised here for the winning shot in a game of shuffleboard with students and staff.

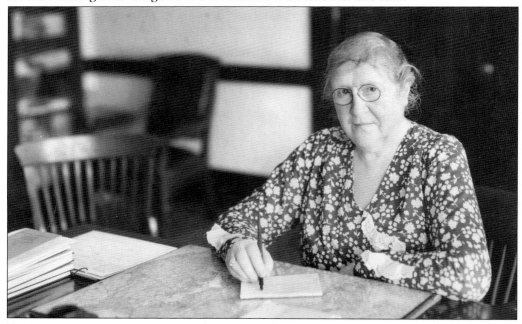

THE END OF THE NORMAL SCHOOL. The year 1934 marked the last year of the Maryland State Normal School. Lida Lee Tall was the last principal of the institution under that name. During the first 14 years of her leadership, the normal school began a period of growth in enrollment and an improvement in academic standards. On May 25, 1934, the State Board of Education expanded the program for elementary teachers and established the B.S. in Education degree. Maryland's normal schools would now be designated as state teachers colleges.

Two

MARYLAND STATE
TEACHERS COLLEGE
1935–1963

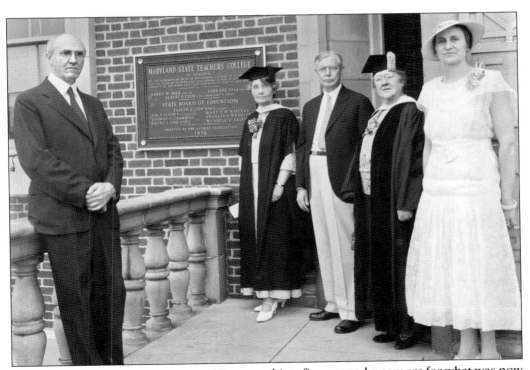

MARYLAND STATE TEACHERS COLLEGE. Nineteen-thirty-five opened a new era for what was now called Maryland State Teachers College at Towson. Present at the installation of a plaque commemorating the name change are (left to right) Dr. Albert S. Cook, state superintendent of schools; Mary Hudson Scarborough, instructor; Frank Purdom, alumni office; Dr. Lida Lee Tall, president; and Ruth Parker Eason, alumni president.

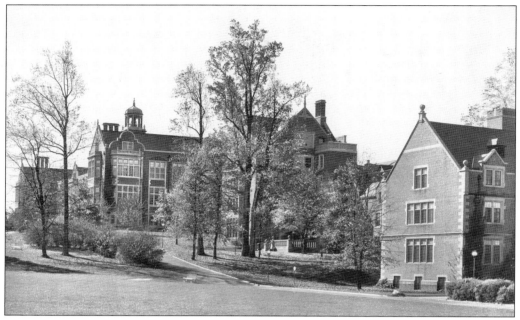

STEPHENS AND RICHMOND HALLS. Stephens Hall, used for administration, faculty offices, and classrooms, and Richmond Hall, the student residences, became familiar sights on York Road in Towson with their unique architectural style. The rolling wooded campus became the destination for commuter students who arrived by car or trolley and the home of residence students. By 1937–1938, 600 students were enrolled.

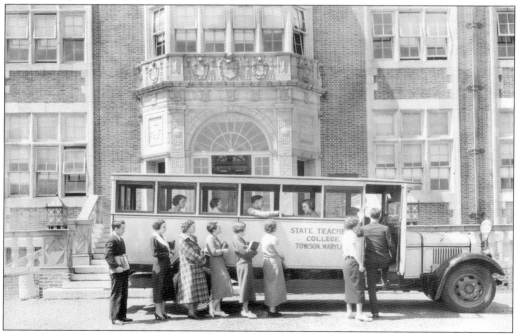

CAMPUS TRANSPORTATION. The campus bus of the 1930s was used to take student teachers to their schools in rural areas such as Cockeysville, Catonsville, or Overlea.

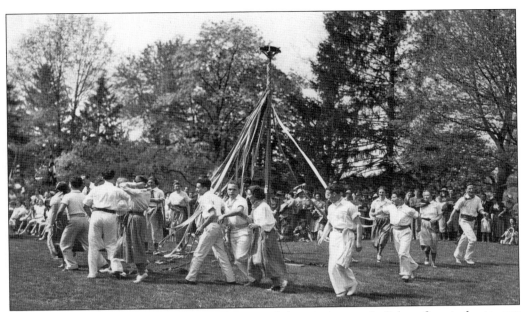

MAYPOLE DANCE. From 1919 until 1969 one of the customary holidays for students was May Day. The senior class president was automatically made "Queen of the May," and she presided over activities such as singing, dancing, games, and the culminating dance around the maypole. The last May Queen and her court were chosen in 1969. The spirit of May Day was kept alive with Tiger Fest.

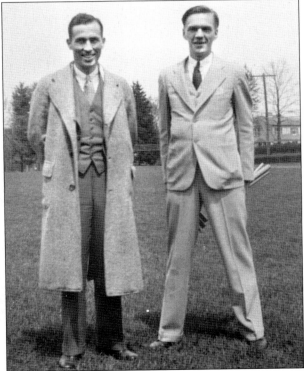

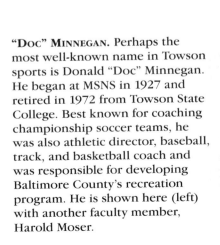

"DOC" MINNEGAN. Perhaps the most well-known name in Towson sports is Donald "Doc" Minnegan. He began at MSNS in 1927 and retired in 1972 from Towson State College. Best known for coaching championship soccer teams, he was also athletic director, baseball, track, and basketball coach and was responsible for developing Baltimore County's recreation program. He is shown here (left) with another faculty member, Harold Moser.

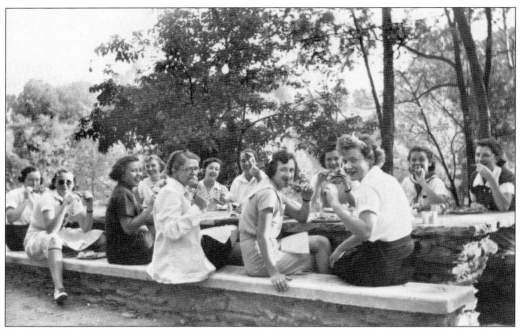

WOMEN'S ATHLETIC ASSOCIATION. The Women's Athletic Association, to which all female students were expected to belong, was at the heart of an educational philosophy that included physical fitness. As illustrated by this picture of the association's picnic in the Glen in 1936, it became an important part of student social life.

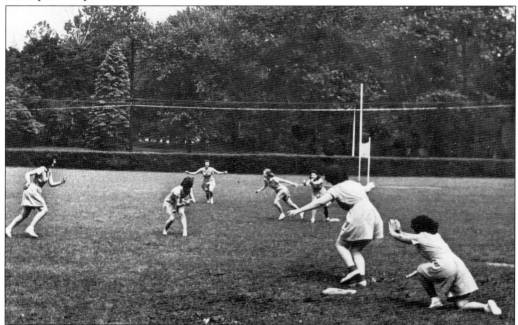

INTRAMURAL ATHLETICS. Softball and other athletic games on the lawns in front of Richmond and Newell Halls became a traditional part of campus life. This women's game in 1936 suggests that the games were played with much enthusiasm.

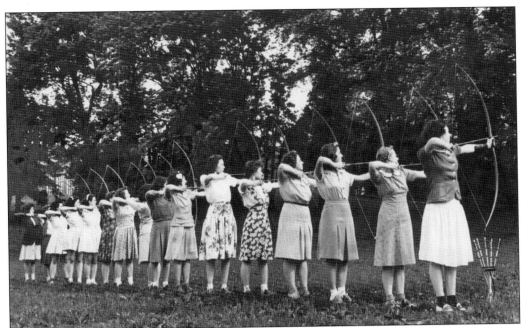

DEMONSTRATION OF ATHLETIC SKILLS. The focus of the teachers college to produce teachers with "healthy bodies and healthy minds" encouraged all students to participate in some sort of athletic activity. The women's archery class shown here demonstrates their skills as part of homecoming events.

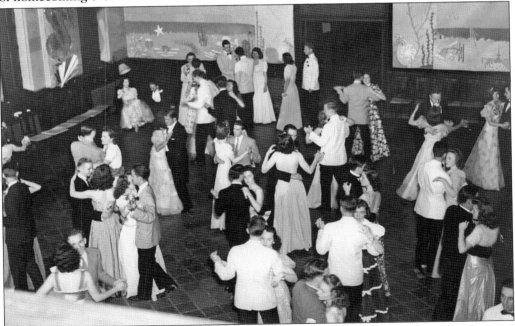

JUNIOR-SENIOR PROM. The academic year at the Maryland State Teachers College (STC) ended in late spring with a junior-senior prom. Within six months of this idyllic dance scene in May 1941, many of the students would be called away to war.

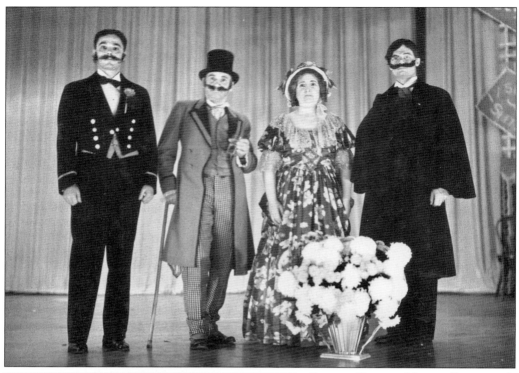

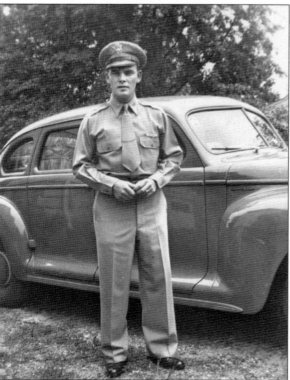

FACULTY FOLLIES. It's a well-accepted fact that many faculty members are frustrated actors and performers. An annual tradition at Towson until the mid-1960s was the Faculty Follies. Here was a chance to throw off the restraints of being "role models" for prospective teachers and show off hidden talents.

TOWSON AND WORLD WAR II. During World War II, the college, by means of a newsletter, kept in close touch with its men and women in the armed forces. Dr. Rebecca Tansil, Dr. Donald Minnegan, Miss Merle Yoder, and others wrote about events and included excerpts from the letters received from those in the various services. Shown here is Charles Gross, class of 1941, who was killed in the war.

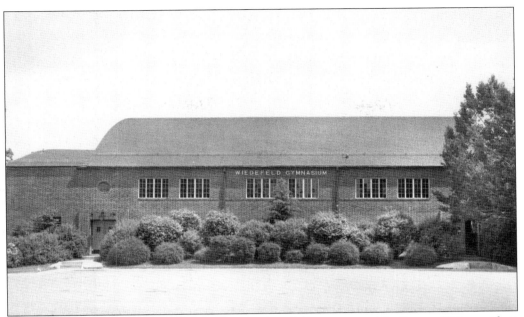

WIEDEFELD GYM. Wiedefeld Gymnasium, erected in 1942, was named for former STC president Dr. M. Theresa Wiedefeld. In addition to physical education classes and athletic events, numerous proms and dances were held in the gym. It was demolished in 1968 to make room for the new Cook Library.

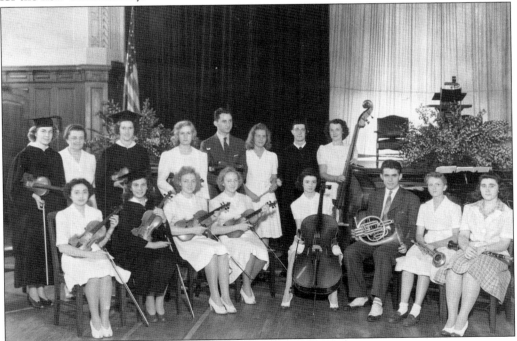

COLLEGE ORCHESTRA. The college orchestra of 1942 was a modest group, not much larger than its predecessors of earlier years. What is notable, however, is the small number of male musicians—a reflection of the war's impact on college enrollments.

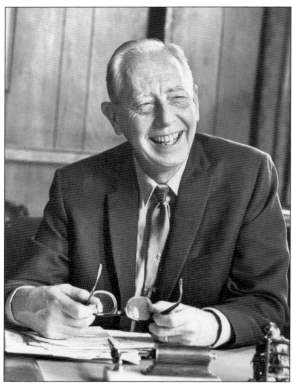

Pres. Earle T. Hawkins. Earle T. Hawkins was president from 1947 to 1969. In 1947, student enrollment totaled 600. When Dr. Hawkins retired, enrollment had risen to over 8,000 day and evening students. Dr. Hawkins gave Towson 22 years of capable and devoted leadership.

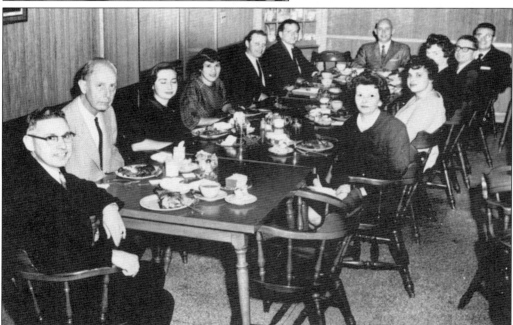

Alumni Association. All graduates of the State Teachers College automatically became members of the alumni association. President Hawkins, second from the left, next to Q. D. Thompson, class of 1942, joins the alumni association officers in the faculty dining room in 1962.

CHEERLEADERS. As more young men returning from the war enrolled in college, and as intercollegiate athletics began to mature, cheerleading became a more prominent activity. These cheerleaders from 1947 are hopefully posed in a "V" for victory.

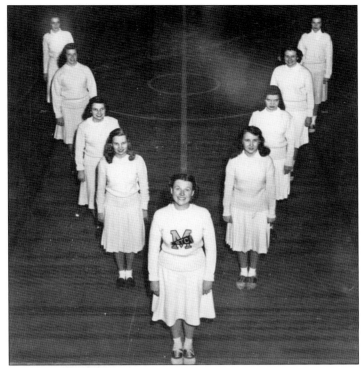

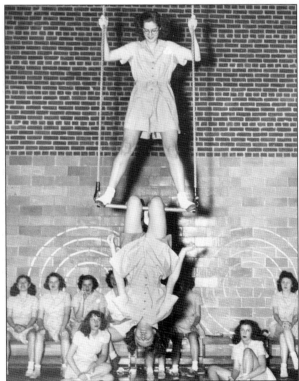

DEMONSTRATION NIGHT. Demonstration Night (shown here in 1948) was a popular annual spring event at which female students from each year's class competed against one another in athletic skills, as well as performing skits and singing.

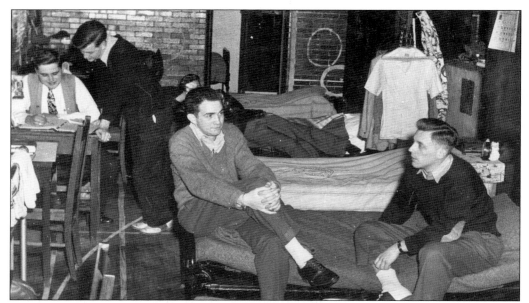

THE MEN'S BARRACKS. The barracks or dormitory for male students was located on the upper floor of the power plant. Each day, the men had to move their beds and furniture to make room for the physical education classes.

WARD AND WEST RESIDENCE HALLS. Ward and West Halls, dedicated in 1951, were the first dormitories built for men. They were named after George Ward and Henry West, former MSNS principals.

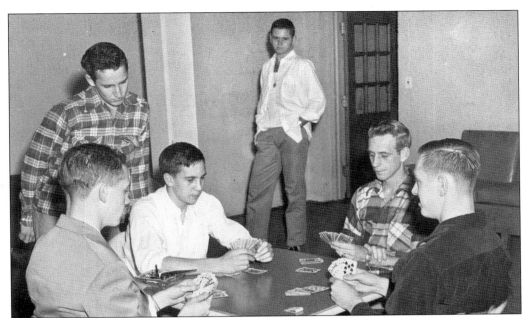

RELAXATION AFTER CLASSES. The benefits of the lounge in the new men's dorms are obvious in this card game in 1952. Students seated at the table from left to right are Clarence Young, Jack Zimmerman, Elmer Sauer, and Al Foster. Looking on is Jack Hogston (standing left) and an unidentified student.

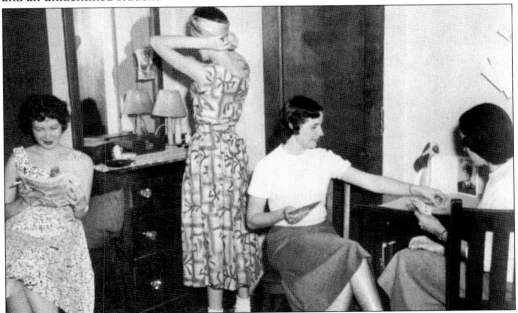

STUDENT DORM LIFE. Dorm rooms were not just for studying but also for socializing and enjoying new friends. But the rules were strict: no one could leave after 10:00 p.m. and no guests after 10:00 p.m.; no men were allowed above the first floor in women's dorms; in the dining room, no bandanas, shorts, or slacks; and no one could sit in a parked car on campus.

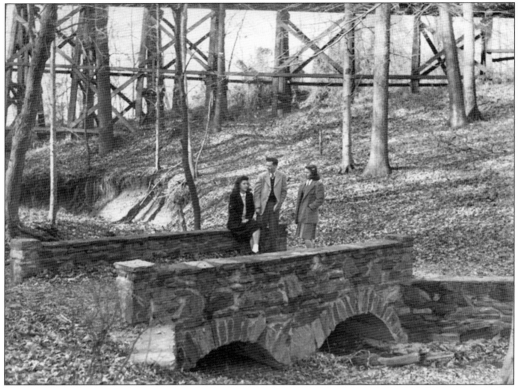

THE GLEN. The Glen was a favorite place for picnics and nature walks. In the background is a railroad trestle from the Maryland and Pennsylvania Railroad.

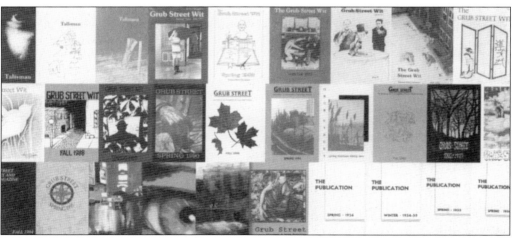

GRUB STREET. Towson's students have always written stories, essays, and poetry. From the earliest days in the 1860s, there were two literary societies to support these ventures. In more recent times, a student literary magazine began publishing in the spring of 1952. Known then as *The Publication*, this magazine evolved into the current *Grub Street*.

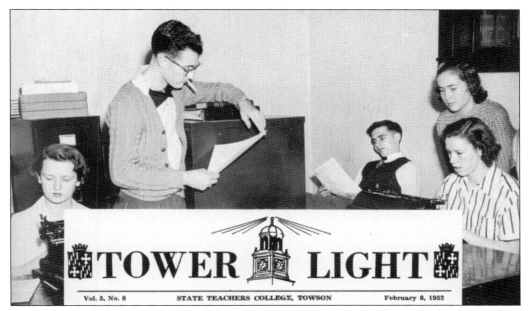

TOWER LIGHT. Another type of student writing was done for the *Tower Light*, the student campus newspaper. Originally called *The Oriole*, the newspaper continues to chronicle campus events and news.

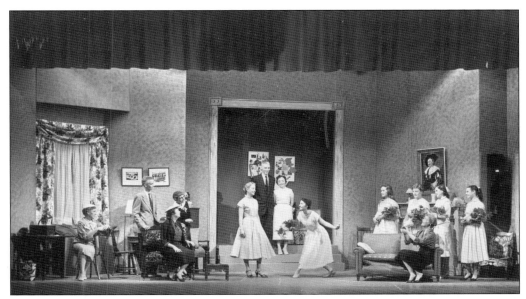

GLEN PLAYERS. The student theater group, the Glen Players, performed several plays each year. Here they are in 1955 performing *Goodbye, My Fancy* in Stephens Hall Auditorium.

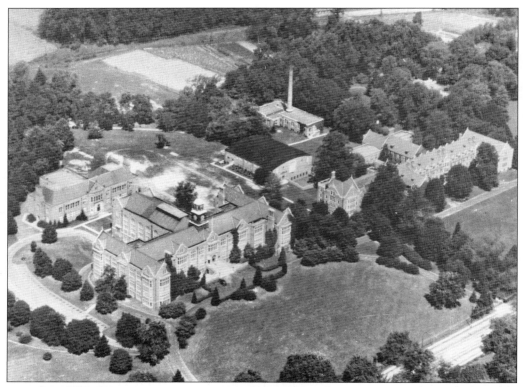

CAMPUS VIEW. At the end of World War II, the campus was comprised of Stephens Hall, the main classroom and administration building; Van Bokklen Hall, which stands behind Stephens; the dormitories; Wiedefeld Gymnasium; and the power plant.

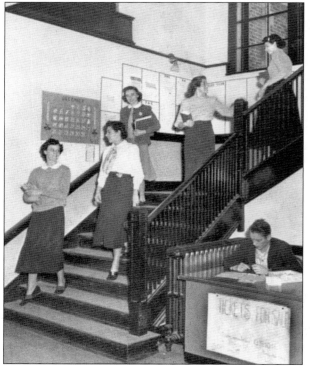

BETWEEN CLASSES AT STEPHENS HALL. As the only classroom building on campus until the mid-1960s, Stephen Hall's stairways and hallways were filled with students going to and from classes.

GRADUATION AT STEPHENS HALL. As the center of campus life, Stephens Hall was often the first and last impression students had of their life at the State Teachers College.

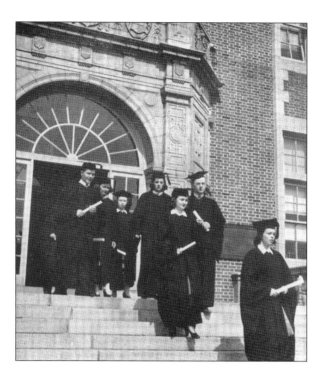

NEWELL HALL FOYER. Newell Hall Foyer, as it appeared in 1956, was a gathering place for the residence students.

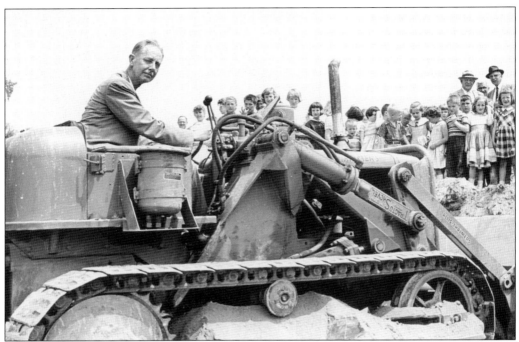

NEW CAMPUS CONSTRUCTION. Pres. Earle T. Hawkins was the president during a period of campus expansion when the baby boomers began to reach college age. Here he leads the way for the groundbreaking for the Lida Lee Tall School in 1959.

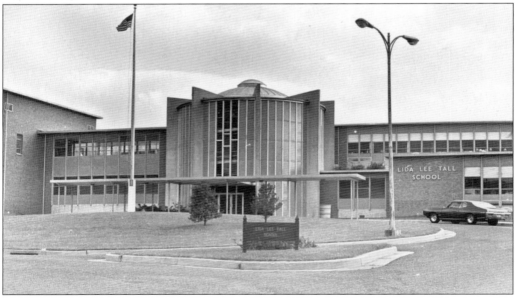

LIDA LEE TALL SCHOOL. Lida Lee Tall Learning Resources Center, which opened in 1960, was the first building on campus that cost more than $1 million to build. It served as the college's model or experimental school for early childhood and elementary teachers until the state withdrew funding for its support in the 1990s. In the new Master's Plan, it is the site for a new liberal arts complex.

DR. WILFRED B. HATHAWAY.
Dr. Wilfred B. Hathaway was one of several who rose from the ranks of the faculty to an administrative role. He was a member of the biology department from 1950 to 1967 and then served as director of the Graduate School from 1968 to 1981. He was also noted for his skills as an organist.

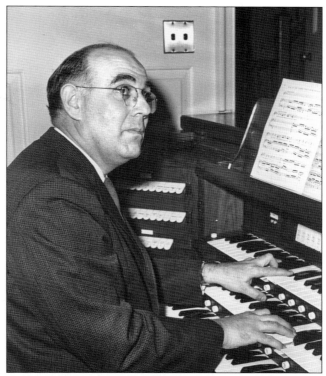

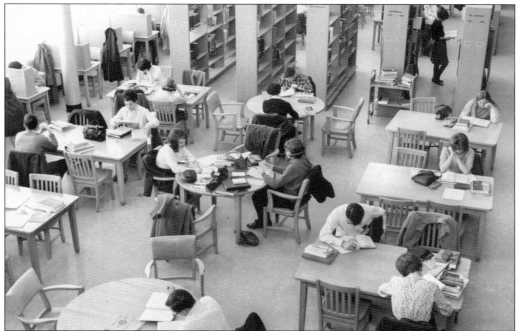

COOK LIBRARY. The first separate library on campus was constructed in 1957. When a larger library, named after State Superintendent of Schools Albert S. Cook, was completed in the summer of 1969, the first building was re-named the Media Center.

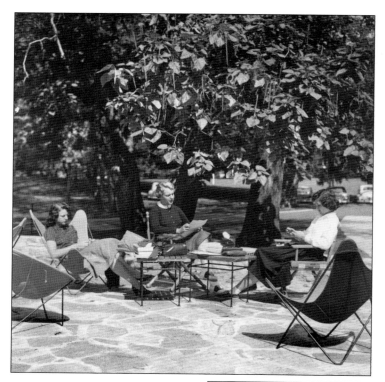

CAMPUS LIFE. Newell Hall patio, outside the Student Center, was an attractive spot to study or socialize while enjoying the spring or summer days.

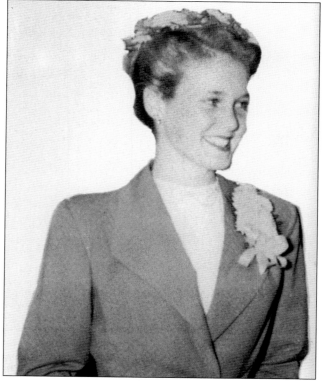

FIRST HOMECOMING QUEEN. The first postwar homecoming was in 1949, but it was not until 1952 that the first homecoming queen, Peggy Whiteleather, was chosen. Homecoming became a day for alumni to return to campus for a parade and to attend performances in the arts and sporting events.

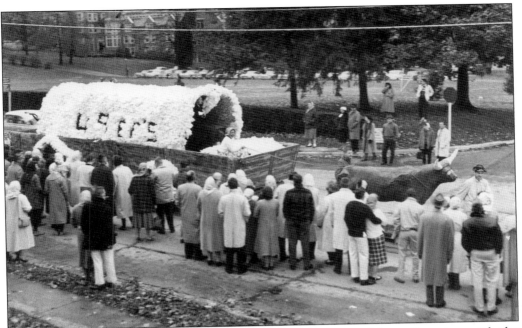

HOMECOMING. Spectators line up along York Road in front of the college to watch the homecoming floats.

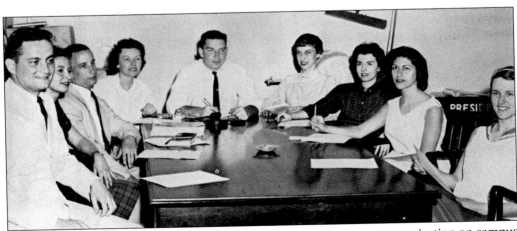

STUDENT GOVERNMENT ASSOCIATION. By the 1960s, the most important organization on campus was the Student Government Association. Many successful business leaders or political figures in Maryland got their first taste of leadership in the SGA.

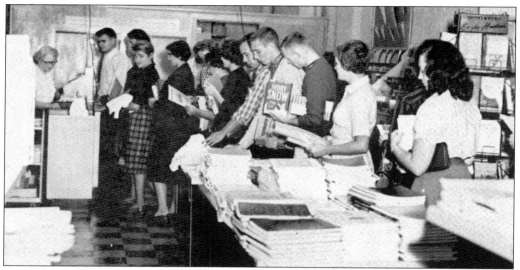

BOOKSTORE. The bookstore or supply store was one of the first stops after successfully registering for classes.

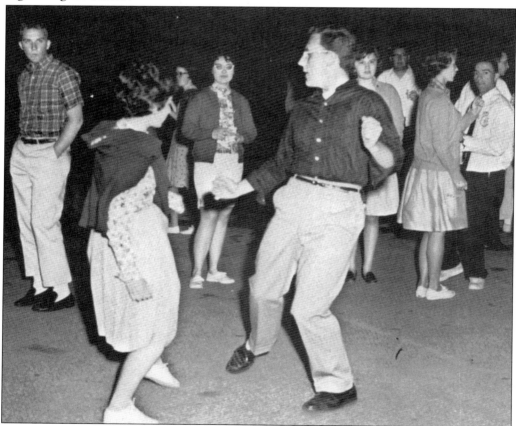

THE TWIST. Dancing around the maypole might have been the old tradition since the early 20th century, but the Twist was more in tune with student interests by the 1960s.

BUCK HARMAN. Wayne "Buck" Harman, class of 1957, was one of the products of Doc Minnegan's soccer program. He was selected to the All-American Soccer Team in 1956, as well as being recognized for All-Mason-Dixon and All-Southern. He later became a teacher and principal in Baltimore area schools.

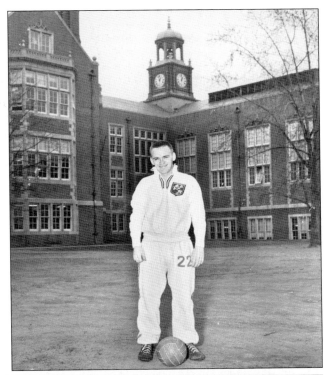

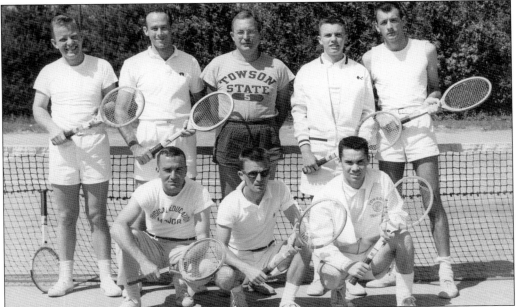

MEN'S TENNIS TEAM. Dr. John McCleary, professor of European history, was the longtime coach of the men's tennis team, continuing even after his retirement from the classroom. Dr. Fred Arnold (back row, far right), a star tennis player, a leader on the men's basketball team, and a member of the Towson Athletic Hall of Fame, went on to serve for many years as the associate dean for graduate students.

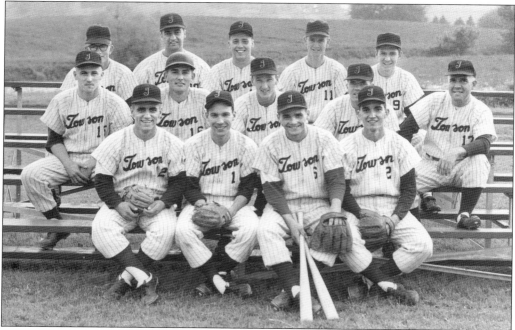

BASEBALL TEAM, 1960. The 1960 baseball team included several future Towson Athletic Hall of Fame members—George Henderson, first row, second from left; Don McGhay, third row, far left; and John Schuerholz, first row, far right. Schuerhdz later became the general manager of the Atlanta Braves.

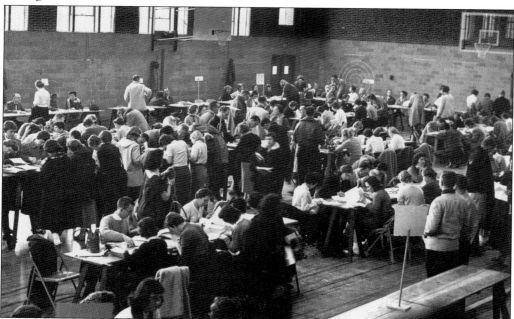

REGISTRATION. Before the era of computers and online registration, every student faced the challenge of registering in person for classes. In the early 1960s, students lined up in Wiedefeld Gym to select courses and to pay bills.

Three

TOWSON STATE COLLEGE
1963–1976

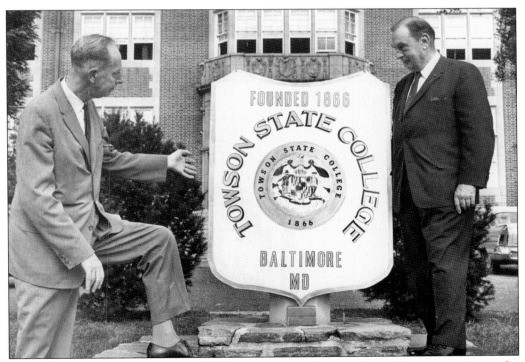

TOWSON STATE COLLEGE. Indicative of the school's growth and broadening scope was the change in name in 1963 from State Teachers College to Towson State College. Towson has become the second-largest public institution of higher education in Maryland. Pres. Earle Hawkins and State Superintendent of Schools Thomas G. Pullen Jr. admire a sign displaying the college's new name.

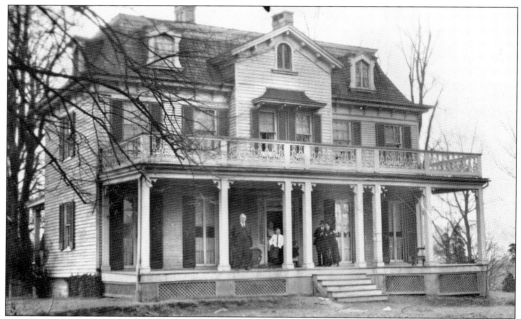

THE COTTAGE. At various times, the Cottage has served as a residence for faculty, as the health center, and as housing for other college employees and for male students. In 1964, the Cottage was torn down to make room for the new physical and natural sciences building.

SMITH HALL. Named after George LaTour Smith, a science teacher at the normal school from 1874 to 1888, this modern facility of laboratories and science classrooms represented Towson's move to a new era.

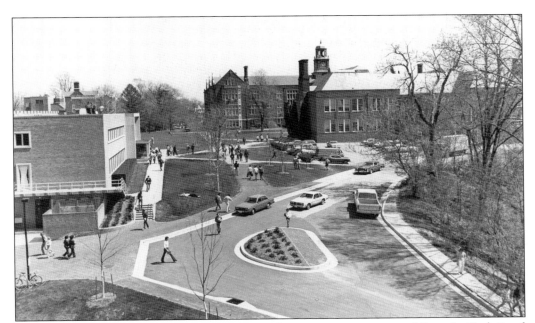

A GROWING CAMPUS. By the 1960s, the campus began to grow westward from its York Road origins. This scene shows Stephens Hall and Van Bokkelen in the background, the edge of the Glen to the right, and the library to the left.

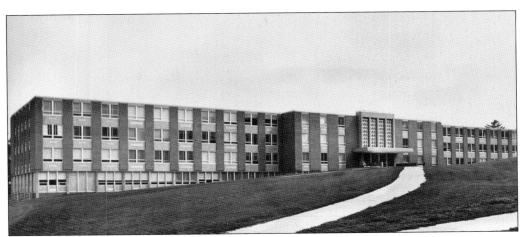

LINTHICUM HALL. Completed in the spring of 1968, Linthicum Hall became one of the most heavily used classroom buildings on campus. Home for the liberal arts and social sciences, it was named after the Honorable J. Charles Linthicum, a member of the House of Representatives from 1911 to 1932 and a 1886 graduate of the Maryland State Normal School. It was through Representative Linthicum's legislative efforts that the "Star-Spangled Banner" became our national anthem.

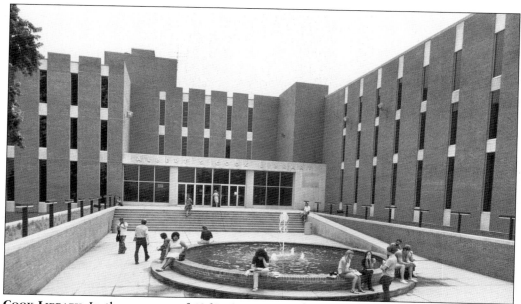

COOK LIBRARY. In the summer of 1969, the new Cook Library opened, and the old library became the Media Center. Albert S. Cook had been the Maryland superintendent of the schools from 1920 to 1942 and had been instrumental in getting legislative support for Towson to become a four-year degree-granting college.

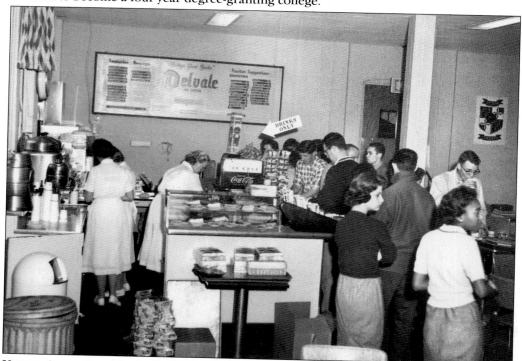

NEWELL SNACK BAR. The "college experience" is often defined not only by the classroom but also by the cafeteria. In the 1960s, the Newell Hall Snack Bar served "Tiger Burgers" and thick chocolate shakes to students.

A CO-ED CAMPUS. Both the expansion of Towson's curriculum to include more of the arts and sciences and the post–World War II boom in higher education led to a change in the student population. Now the mix settled into a 60/40 ratio of females to males.

A COMMUTER CAMPUS. Much of Towson's growth was also due to the commuter student. The search for a parking place took on a role only a few notches below the search for the right class or the best instructor.

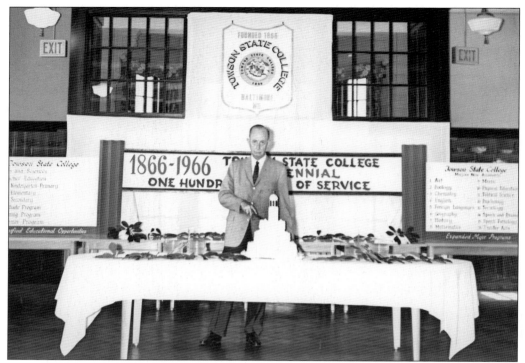

CENTENNIAL CELEBRATION. President Hawkins presided over many events held in honor of Towson's 100th anniversary.

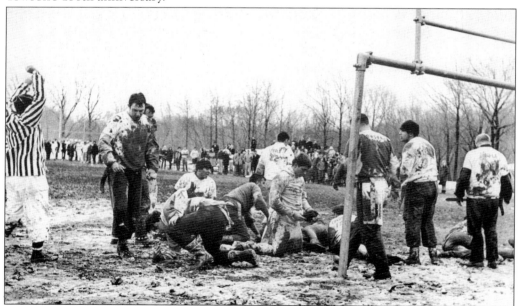

MARATHON FOOTBALL. Begun in 1966 with Loyola College in an effort to break the Guinness world record for longest football game, marathon football became a charity fund-raiser. By its fourth year, the event involved over 2,000 students from area colleges and attracted participation by Brooks Robinson and other Baltimore celebrities.

GRADUATING SENIORS RECEPTION. Graduating seniors are welcomed by Pres. Earle and Mrs. Hawkins.

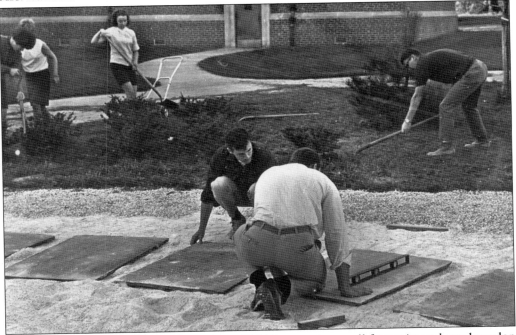

GIFT FROM THE CLASS OF 1967. The class of 1967 created a small fountain and pool garden between Prettyman and Scarborough dormitories as their gift to the college. The students built the garden themselves.

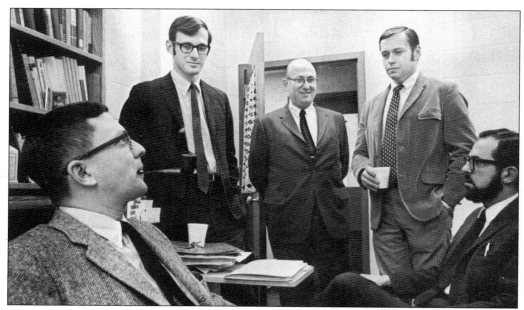

FACULTY. At the heart of every college or university is the contact between students and faculty. During the 1963–1976 period, the number of faculty increased from 167 to 513 in order to meet the growing student enrollment. Pictured here from left to right are history department faculty members Dr. Joseph Cox, Dr. Dean Esslinger, Dr. Arnold Blumberg, Dr. Harry Piotrowski, and Dr. Victor Sapio.

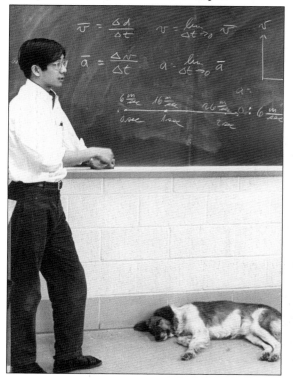

HENRY AND FRIEND. As Towson evolved from its roots as a teachers college into a liberal arts and sciences-based institution, its faculty took pride in the quality of teaching. Dr. Henry Chen and his "friend" were a popular combination for many physics students.

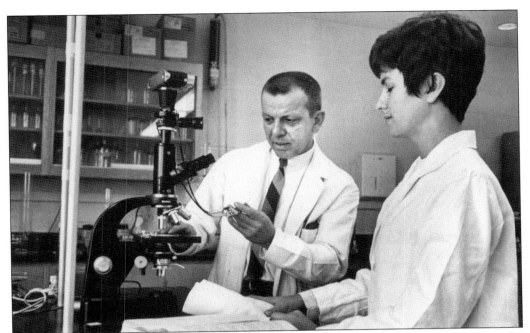

STUDENT RESEARCH. Students learned to do research in laboratories, libraries, and in the community alongside the faculty. Here Harold Muma instructs a student in his biology class how to photograph a microscope slide.

PROFESSIONAL EDUCATION. Besides growth of the liberal arts and sciences, the 1960s and 1970s saw the college lay the basis for its professional schools and departments. Dr. Bong Ju Shin was an early member of the economics department, which later became part of the College of Business and Economics, one of the largest in the university.

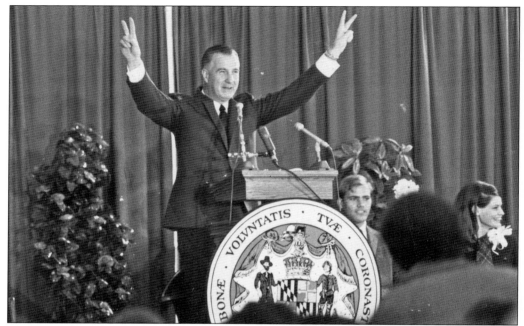

AGNEW FOR VICE PRESIDENT. National attention came to the campus in the fall of 1969 when Gov. Spiro Agnew held a rally in Burdick Gymnasium. Agnew was a former Baltimore County executive and longtime resident of the Towson area. Both of his daughters were students at Towson State College.

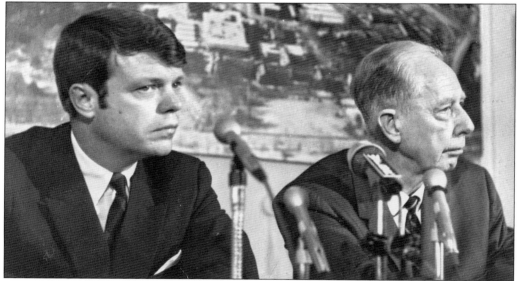

NEW LEADERSHIP. The school year 1968–1969 was the 22nd and final year of President Hawkins's administration. He had been the school's leader during the transition from normal school to liberal arts and science college. Not only did he oversee the growth of the curriculum but also the physical growth of the campus. Property for expansion was purchased from Shephard-Pratt Hospital, and new buildings were constructed. The institution he handed over to his successor, James L. Fisher (left), was poised for a new period of development.

JAMES L. FISHER, PRESIDENT, 1969–1978. The university's first leader from the Midwest, James L. Fisher, came to Towson with considerable experience at various levels of university administration. Dr. Fisher was an extraordinarily active president and left a significant imprint on the university. Among his accomplishments were the creation of four vice-presidential positions, the establishment of positions for five academic deans, the founding of the Academic Council as a legislative and advisory body of faculty and students, the formation of the Office of Institutional Development, the addition of a winter session and expanded graduate and continuing education programs, and the development of new programs in nursing, occupational therapy, and business. Thirteen new buildings were constructed under his tenure, and the enrollment climbed from 5,727 to 10,762.

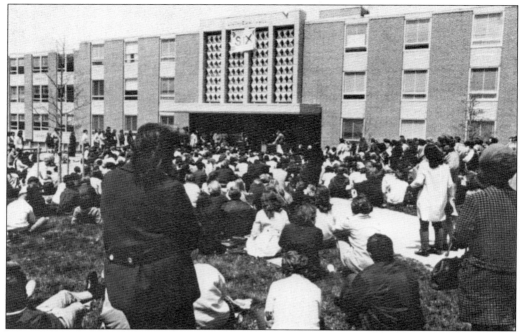

ANTI–VIETNAM WAR PROTESTS. Towson's suburban campus was not immune to the political protests of the day. On October 15, 1969, students filled the lawn in front of Linthicum Hall to support the National Moratorium on the war in Vietnam.

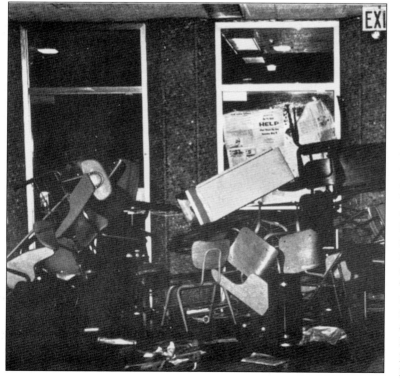

LINTHICUM SIT-IN. During the evening of May 10, 1972, a group of anti-Vietnam war protesters staged a takeover of Linthicum Hall. They chained the doors and created barricades with furniture. After four hours, campus security officials were able to cut the chains off of the doors and enter Linthicum Hall. Nineteen people submitted peacefully to arrest.

NURSING. The Nursing Program accepted its first students in the spring semester of 1972. It was the first such program to be offered by a school in the Maryland State College System. By 1975, the Nursing Program received accreditation from the National League for Nursing.

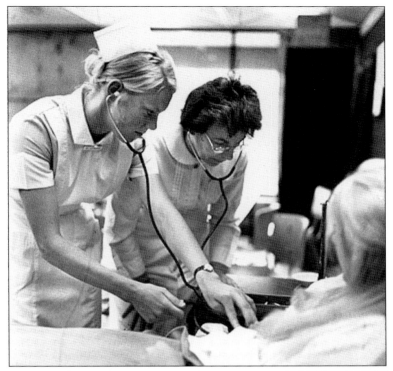

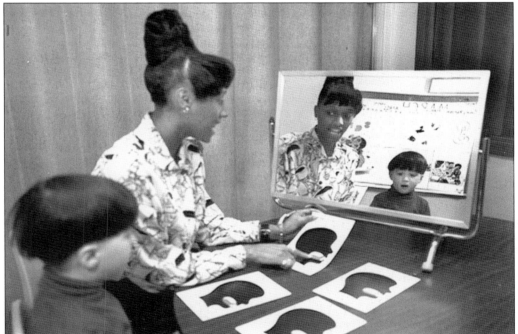

SPEECH HEARING CLINIC. One of Towson's early outreach programs was the Speech Hearing Clinic. Established in 1964, the clinic provided a laboratory for audiology and speech pathology students to work with children and adults from the community.

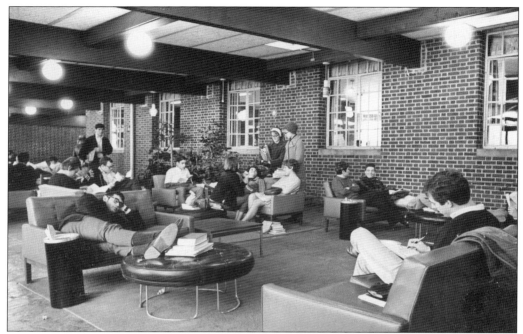

STUDENT LIFE, 1970s. While student protests occurred from time to time in the 1970s, the majority of students led a more sedate life. The Student Center at Newell Hall was more often the site of students relaxing or studying than protesting.

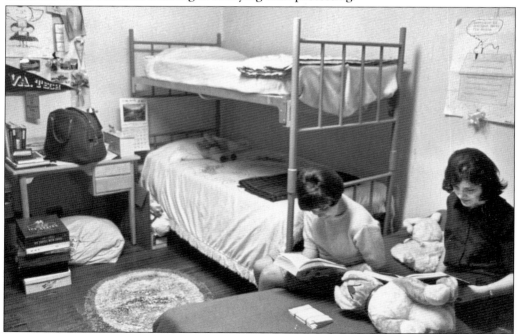

RESIDENCE LIFE. Dorm rooms on campus may have lacked the computers, microwaves, and other amenities of later years, but students filled them with the books and personal touches that created home and study space.

THE "DEANS" OF STUDENTS. The dean of students under President Fisher was former theatre department faculty member Richard Gillespie. The challenges and problems he faced during the student activist days of the 1970s were much different from those of his predecessor, Dean Orrielle Murphy. Here they share a lighter moment at the 1970 Alumni Dinner.

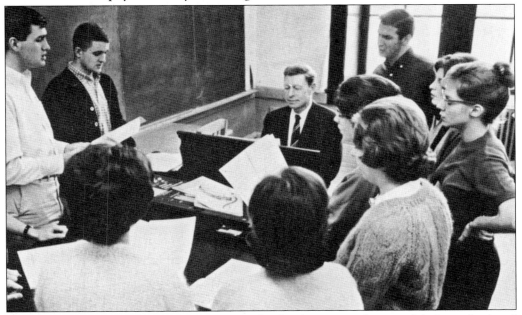

DR. CHARLES HASLUP. It was not uncommon for faculty to spend most of their professional career at Towson. Charles Haslup, a graduate of the class of 1938, was a member and later chairperson of the music department. Between 1966 and 1983, he served as assistant to the president under four presidents. Even in retirement, he continued to carry out special projects for the college.

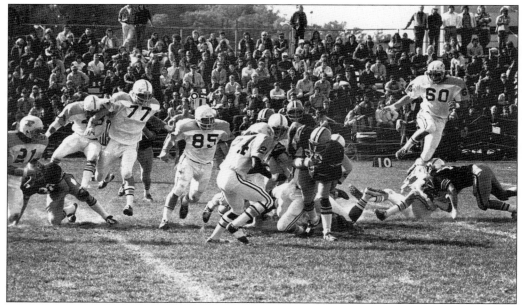

A Perfect Season. The year 1974 was a memorable year for Towson athletics. The college fielded its first Division III intercollegiate football team in 1970 and by 1974 completed its first undefeated season under Coach Phil Albert. Towson was the only Division III team in the country to achieve 10 wins and no losses.

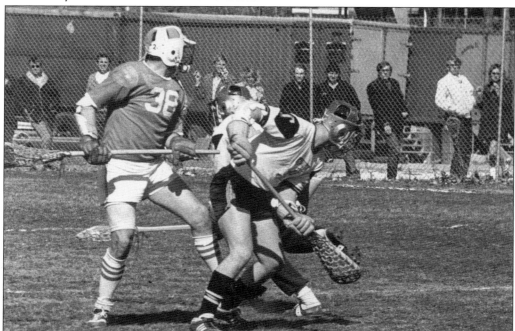

Lacrosse National Championship. Coach Carl Runk directed Towson's 1974 men's lacrosse team to its first national championship. Located in the heart of the Mid-Atlantic lacrosse region, Towson became a perennial contender for winning its league and for being the top team in the Baltimore area.

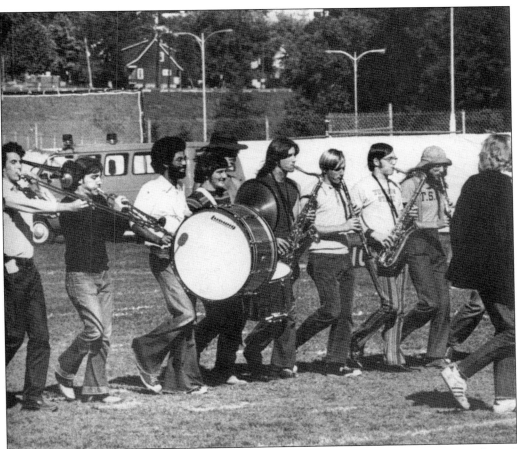

FOOTBALL BAND. The 1974 football band was a volunteer group of students whose "uniforms" were of the non-conformist style of the 1970s generation.

STUDENT GOVERNMENT ASSOCIATION. Like presidents before him, President Fisher encouraged students to participate in organizations and activities and to learn the fundamentals of good leadership. The Student Government Association by the 1970s was the primary student organization on campus.

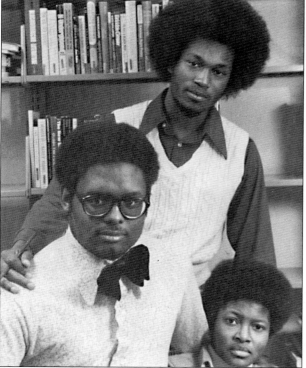

STUDENT LEADERS. Two officers of the SGA who went on to Maryland leadership positions were David Nevins and Ann Marie Lowe Daugherty. David Nevins became a leading businessman, advisor to state politicians, and chairman of the Board of Regents of the University System of Maryland. Ann Marie Lowe Daugherty became a long-term member of the Maryland House of Delegates.

BLACK STUDENT UNION OFFICERS, 1974–1975. Towson's African American students formed the Black Student Union in the late 1960s. Besides generally raising awareness of the diversity of the student population, the group helped develop the African-American Cultural Center in 1974 and the Black Studies Program. Pictured here are Darryl Wright, Morris Campbell, and Shelia Culbertson.

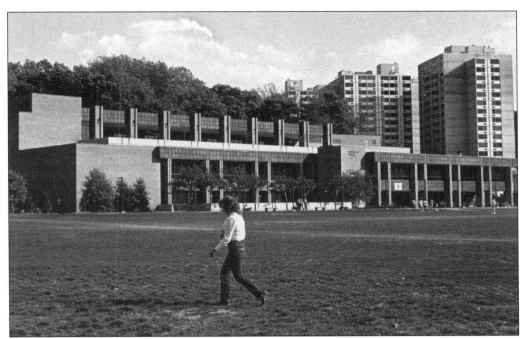

THE COLLEGE UNION. The College Union opened in 1972. Its name was changed to the University Union in 1976, when the name of the school changed to Towson State University.

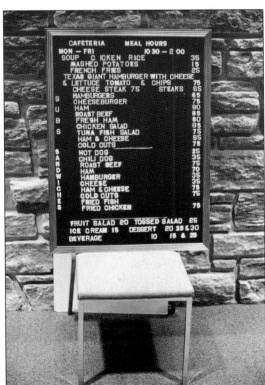

CAMPUS FOOD. Students were able to buy lunch for $1.00 or less in the new union.

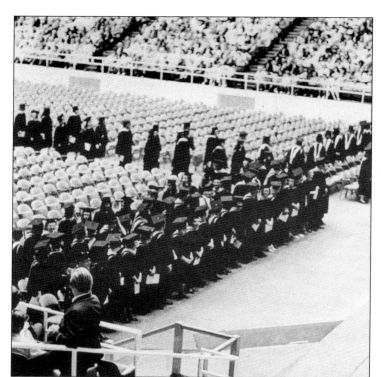

COMMENCEMENT CEREMONIES. The growth of Towson State College could be measured by the increasing number of graduates whose families attended commencement. By 1970, commencement had outgrown the old venue of the Glen Esk lawn and was held for the first time in the Baltimore Civic Center.

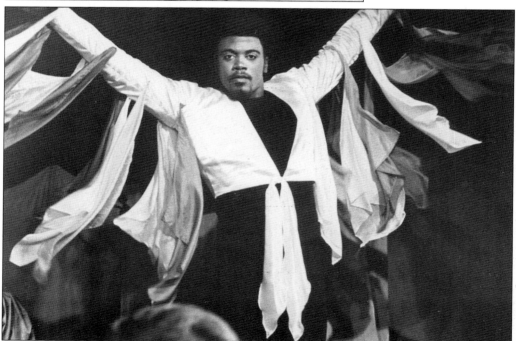

HOWARD ROLLINS. While student groups like the Glen Players had established a solid tradition in Towson's history, the new theatre department flourished with actors like Howard Rollins, seen here in the 1969 production of *Christopher Columbus*.

HANK LEVY. One of the true "stars" of the Towson faculty was Henry "Hank" Levy of the music department. He created the Towson State Jazz Ensemble, one of the best college jazz bands in the nation. He also was an arranger for artists like Stan Kenton.

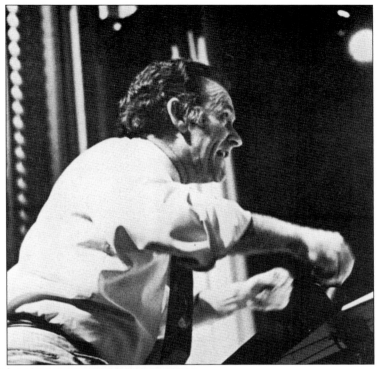

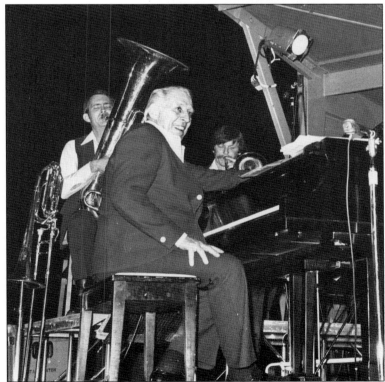

STAN KENTON. Levy's success and that of the Towson State Jazz Ensemble brought national attention to the campus. On July 29, 1973, Stan Kenton and his "Jazz Orchestra in Residence" performed on Burdick Field with Hank Levy and the Towson State Jazz Ensemble for a crowd of 5,000.

73

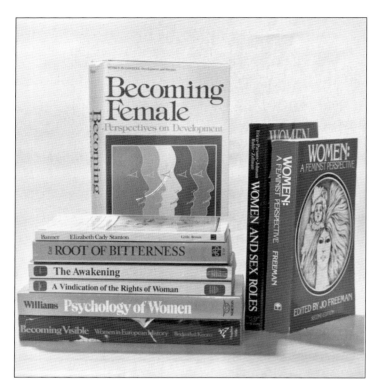

WOMEN'S STUDIES. The Women's Studies program was established in 1973, making it the second-oldest in the United States. On its 30th anniversary in 2003, it became an academic department.

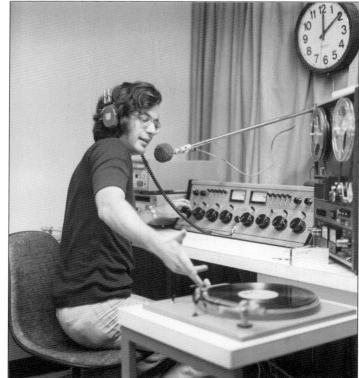

TOWSON RADIO. On February 12, 1976, Towson's radio station, WCVT-FM, went live. Later, in September 1991, the call letters were changed to WTMD, which means "Where Towson Makes a Difference.

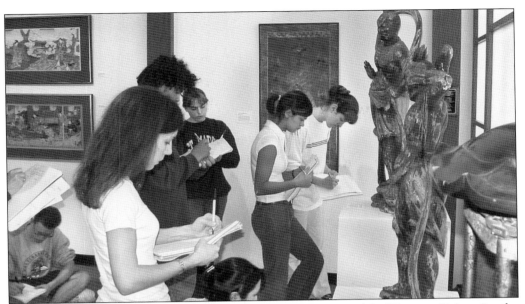

ASIAN ARTS AND CULTURAL CENTER. Described as one of the "jewels" of Towson University, the Asian Arts and Culture Center brought world-class artists and performers to campus. The small but fine gallery and the professional performances enrich the education of students and the Maryland community.

FINE ARTS BUILDING. Opening in the fall of 1973, the Fine Arts Building became the home of the music, art, and theatre arts departments. The building was designed to accommodate public performances and exhibits as well as provide classrooms and studios for budding performers to hone their artistic talents. The now-named Center for the Arts has been recently renovated and enlarged.

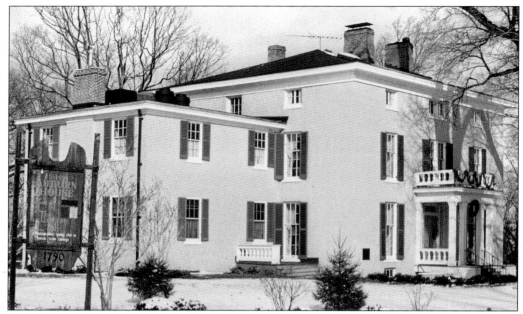

AUBURN HOUSE. Originally built in 1790 by Charles Ridgely, Auburn House is used by the university for special events and for office space. The house was destroyed by a fire in 1849 and was rebuilt in 1850. Towson University acquired the property in 1971 and opened a short-lived dining club for the university community in 1976.

STUDENT DAY CARE CENTER. The second-oldest continually operating student day care started in 1972 with eight children. Over the last 30 years, the center has helped students with children to have a successful academic career by providing a day center environment on campus.

A PLACE TO LEARN. Outside of classes, students, especially commuters, found whatever quiet place they could where they could read and catch up on homework.

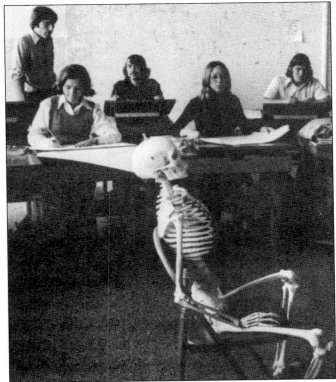

ANATOMY OF A CLASS. One of the strengths of Towson State College was the quality of the teaching. While some students might have felt that a class lasted too long, the majority was enthusiastic about the emphasis on learning

77

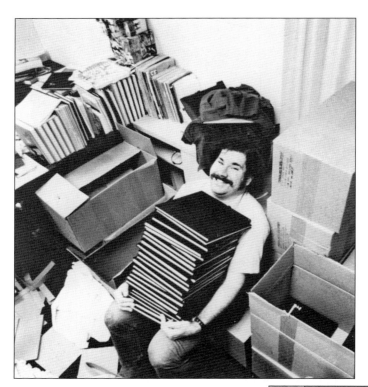

TOWER ECHOES. The first yearbook was issued in 1902 with the name *Aletheia*. Through the years, it has had a variety of names and finally became entitled *Tower Echoes* in 1949.

TOWSON STATE UNIVERSITY. On July 1, 1976, as the nation celebrated its 200th anniversary, Towson State College changed its name to Towson State University. This was the fourth name for the school founded 110 years earlier in 1866.

Four

TOWSON STATE UNIVERSITY
1976–1997

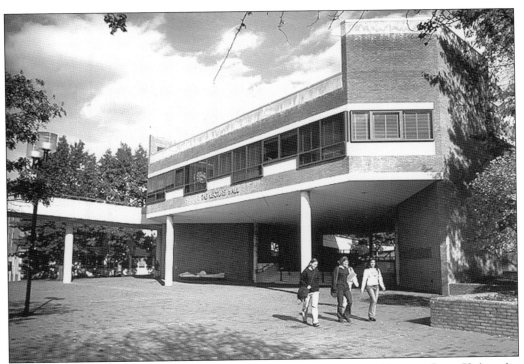

NEW CAMPUS FOR A NEW UNIVERSITY. Towson's change of name to Towson State University coincided with a new building boom as the Lecture Hall (pictured here), Psychology Building, Education Building, and a new sports stadium were opened. A new Towson Center for athletics and physical education was built next to the stadium, and a new wing was added to Smith Hall for the sciences.

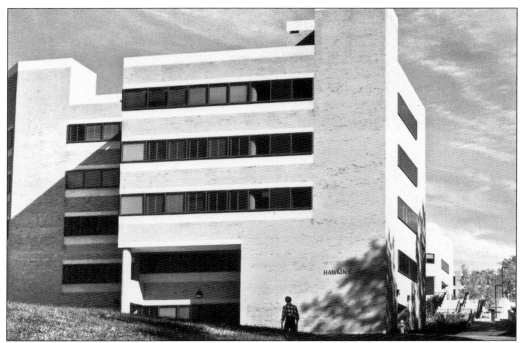

HAWKINS HALL. The education building, Hawkins Hall, was named after Towson State College president Earle T. Hawkins. It opened in 1977.

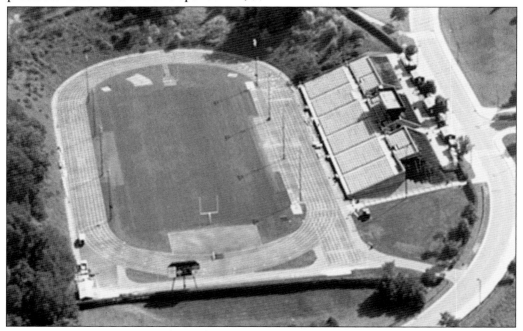

MINNEGAN STADIUM. In 1983, the stadium was renamed in honor of Donald "Doc" Minnegan, a man who devoted over 40 years of his professional life to Towson. From 1929 to 1971, Minnegan was a teacher, coach, chairman of the physical education department, and athletic director.

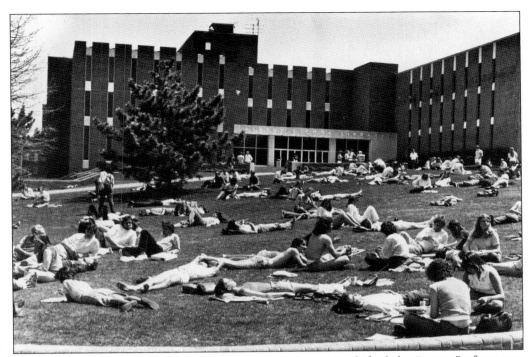

THE BEACH. The completion of new buildings in the 1970s shifted the "center" of campus away from the older buildings along York Road. The new center, in front of Cook Library and between Linthicum and Smith Halls, became a favorite gathering place for students between classes. On sunny warm days, it earned its new nickname "The Beach."

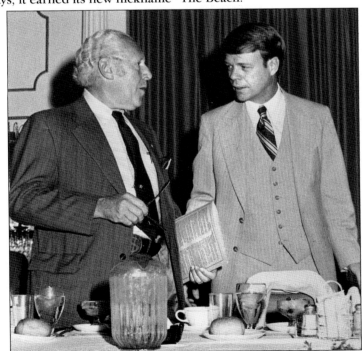

PRESIDENT FISHER MOVES ON. At the end of the 1977–1978 academic year, President Fisher (right) left Towson to become the head of a national foundation in Washington. During his nine years at Towson, he raised the school to university status and brought it to the attention of state leaders like Comptroller Louis Goldstein, shown here with Dr. Fisher.

HOKE L. SMITH, PRESIDENT, 1979–2001. After a one-year search, during which TSU was led by acting president Joseph Cox, the university welcomed its new leader, Hoke L. Smith. Dr. Smith's focus in the next 22 years would be faculty development and building the academic reputation of the university. Under his leadership, Towson would grow as a "comprehensive university" and eventually expand its programs at the master's and doctorate level.

RESIDENT OR COMMUTER. Student life at Towson was shaped not only by faculty and courses taken, but by whether one lived in a residence hall or commuted to campus.

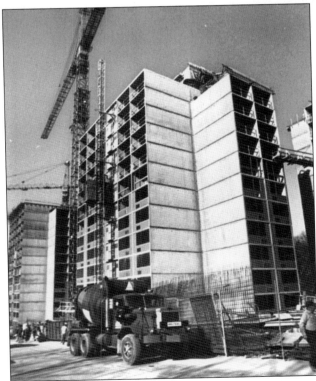

GLEN TOWERS. A significant increase in residence students occurred in the early 1980s after President Smith secured the funding to build the Glen Towers.

A PLACE FOR YOUR STUFF. Students of the old normal school days would have been surprised or fascinated by all of the "stuff" that TSU students brought to their dorm rooms. Refrigerators, microwaves, stereos, and eventually computers were necessities, not luxuries, for most students.

POTOMAC LOUNGE. The Potomac Lounge in the University Union was only one of many places that commuter students found to rest or pass time between classes.

UNIVERSITY STORE. By the 1980s, the University Store offered clothes, gift items, supplies for classes, snack foods, computer accessories, and even textbooks.

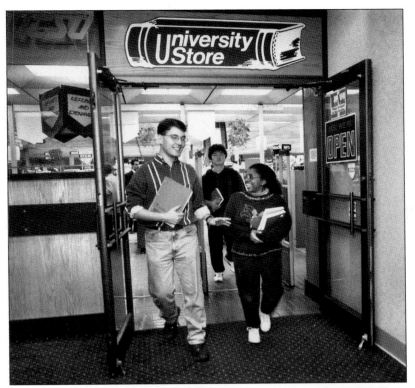

"BRANDING" THE TIGER. A new Towson State University called for a new public image. The tiger, Towson's mascot, became a popular "brand" for promoting the university.

MAN AND WOMAN OF THE YEAR. Each year, Towson selected a Man and a Woman of the Year. The award was based on scholarship, on-campus activities, off-campus involvement, and employment experience. President Smith presented the awards to Todd Negola and Marcy Anderson at the 1993 homecoming.

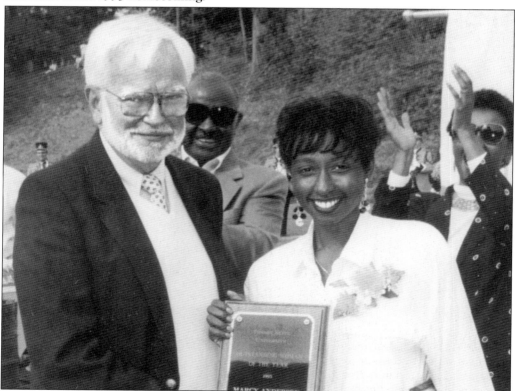

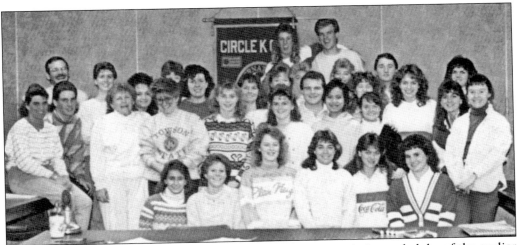

CIRCLE K. Like their predecessors who joined the literary societies and clubs of the earlier school, TSU students created and took part in a wide variety of organizations. Circle K was one of the largest. Students worked with the alumni association on a campus blood drive, raised money for cystic fibrosis, and performed other community work.

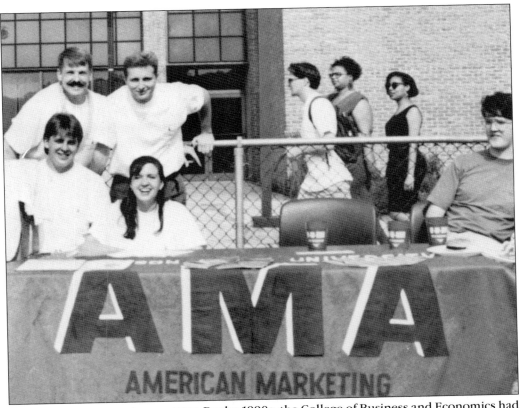

AMERICAN MARKETING ASSOCIATION. By the 1990s, the College of Business and Economics had developed the largest undergraduate business program in the Baltimore region. The American Marketing Association became a popular student organization for business majors to join.

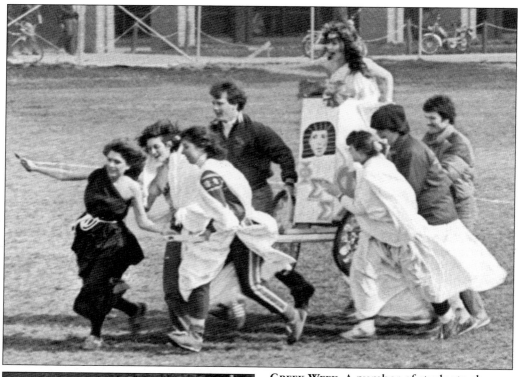

GREEK WEEK. A number of students chose Greek fraternities or sororities for the social opportunities they offered as well as for the charitable and civic projects they supported. Shown here is a chariot race held during Greek Week.

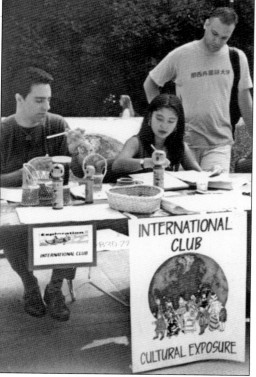

INTERNATIONAL STUDENTS. New to the campus were a growing number of international students. Students from Asia, Europe, Africa, and Latin America, representing 100 countries, became a part of the university community.

INTERNATIONAL PARTNERS. In 1987, Towson State signed its first international partnership agreement with the Carl von Ossietsky Universität Oldenburg in Germany. President Michael Daxner, one of the founders of the partnership, was honored with an honorary degree at Towson's 1990 commencement.

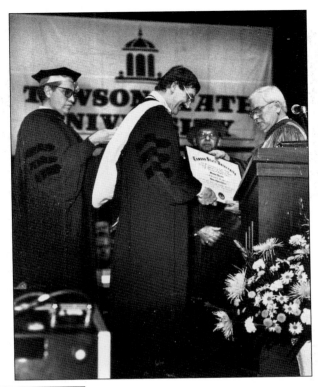

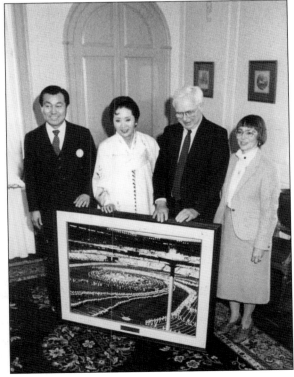

TOWSON IN ASIA. Two key figures in promoting TSU's programs in Asia, particularly South Korea and China, were President Smith and Dr. Park She Jik. Dr. Smith (second from the right) was honored with a doctoral degree from San Kyun Kwan University, and Dr. Park (left), a leader in Korea's national government and head of the 1988 Olympics Committee, was honored in a similar manner by Towson.

ATHLETICS EVENTS. Besides participating in intramural touch football, softball, volleyball, and other sports, students also became fans at intercollegiate games, where they caught the "Tiger Spirit."

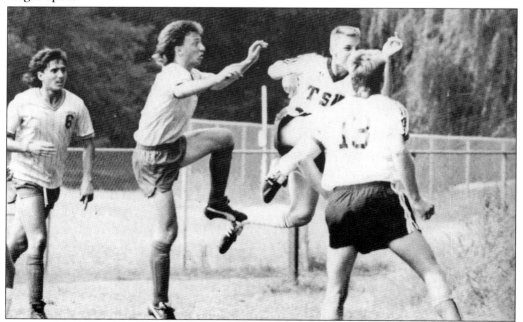

CHAMPIONS. After moving to the NCAA Division I in most sports in 1979 (football became Division IAA in 1987), Towson State teams began to enjoy success by the late 1980s and early 1990s. TSU had 22 intercollegiate programs and had regularly won league championships in soccer, lacrosse, baseball, golf, tennis, women's basketball, and gymnastics.

NCAA-BOUND. The men's basketball team, under Coach Terry Truax, earned its first appearance in the NCAA Tournament by winning the East Coast Conference championship in 1990.

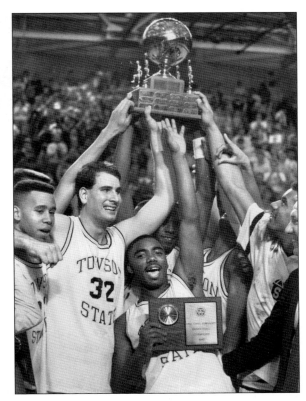

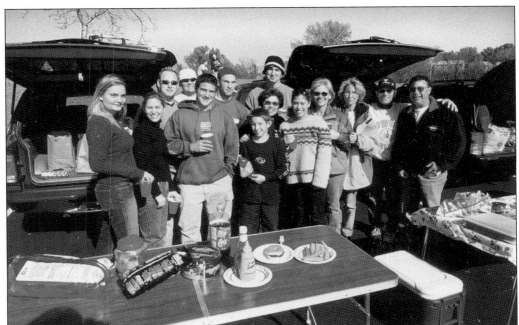

TAILGATING. Tailgating is a favorite "spectator" sport for Towson's alumni, students, and their families.

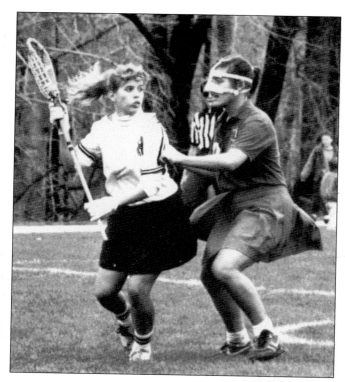

LACROSSE CHAMPIONS. Lead by East Coast Conference (ECC) Player of the Year Colleen Cahil and Coach of the Year Sandy Hoody, the Towson State University women's lacrosse team won its first ECC championship with a 4–3 title game victory over University of Deleware. Shown here is Kelly Bush checking an opponent.

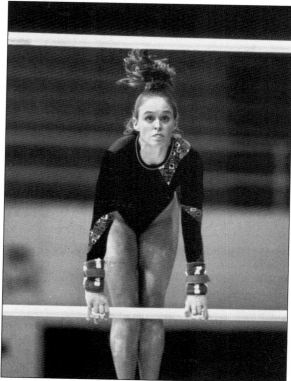

ALL-AMERICAN GYMNAST. Erin Shanley (class of 1997) earned All-American honors for the Tigers on uneven bars and graduated with school records on vault, bars, floor exercises, and all-around.

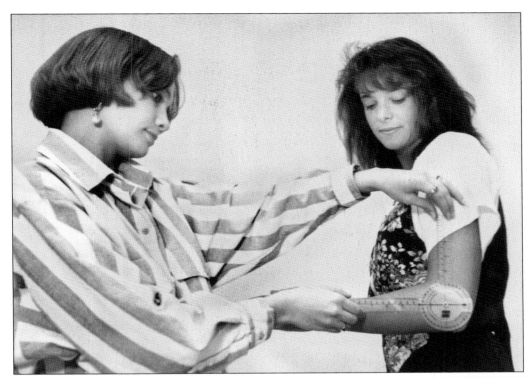

PROGRAM EXPANSION. One of the legacies of President Smith's tenure was the expansion of academic programs, growing from over 60 programs in 1976 to more than 90 programs in 1997. Occupational therapy, for example, added a new master's degree in 1982 and later began the first doctoral program.

MARY CATHERINE KAHL. Towson took pride in the quality of its faculty and their devotion to their students' education. Mary Catherine Kahl, who began at Towson in 1943 as a history instructor and taught for over 45 years, was the first recipient in 1982 of the President's Award for Distinguished Service to the University.

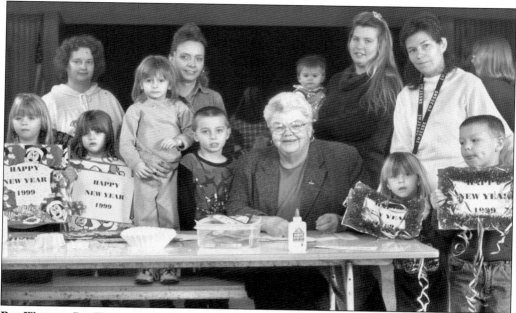

PAT WATERS. Pat Waters, assistant professor of early childhood education, started FACT—Families and Children Together—in 1992 to help parents prepare children for school. Her weekly sessions with parents and their children at Sandy Plains Elementary School had a positive impact on the children because the parents became more involved in their daily education.

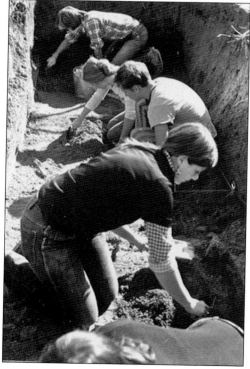

ARCHAEOLOGICAL DIG. In addition to internships and study abroad opportunities, Towson students can take advantage of real field experiences, such as this archaeological dig, in order to gain practical knowledge in their chosen field.

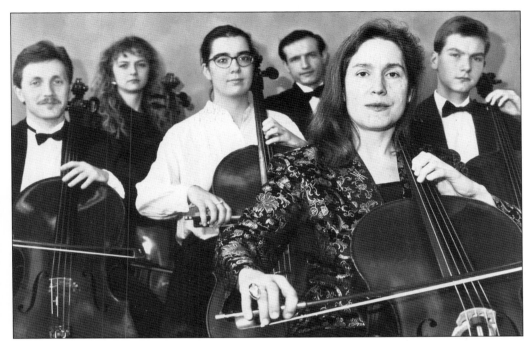

THE PERFORMING ARTS. Artists and musicians, such as cellist Cecylia Barczyk (front right), brought a high level of performance and teaching to TSU. The Maryland Arts Festival, a summer art extravaganza, the Asian Arts and Culture Center, dance and musical programs, art exhibits, and other activities made Towson one of the state's leading institutes for the arts.

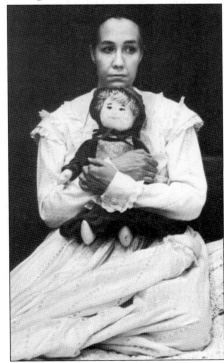

THEATRE ARTS. In 1973, a new Fine Arts Building created an attractive venue for the talent of Towson's faculty and students. Outstanding faculty like Maravene Loeschke, shown here as Emily Dickinson in *The Belle of Amherst*, built Towson's reputation for quality in the arts.

95

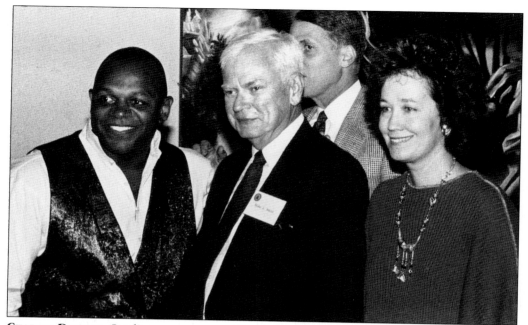

CHARLES DUTTON. Quality programs and faculty attracted talented students and produced successful artists. Charles "Roc" Dutton went from studying theatre at Towson to star in films and his own TV situation comedy, *Roc*.

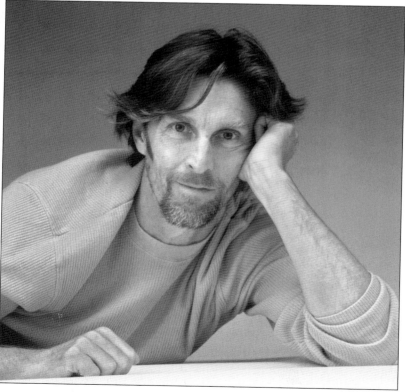

JOHN GLOVER. One of Towson's first theatre graduates became its most successful. John Glover, winner of a Tony Award for his performance in Broadway's *Love! Honor! Compassion!* became a familiar face in Hollywood films and on television. Many would recognize him as Lex Luther's father in the television series *Smallville*.

ALUMNI SUPPORT. Towson has always enjoyed strong support from its alumni. Haven Kolb (right) presented a check on behalf of the class of 1936 to John Suter, associate vice president of Institutional Advancement.

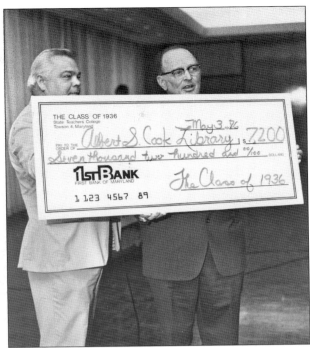

ALUMNI RECOGNITION. Begun in 1958, the Distinguished Alumni Award is given to alumni "who have been outstanding in their chosen field of endeavor and who have made significant contributions which have benefited their community, state or nation." Elizabeth Hartje (class of 1931) received this award in 1983 for her achievements in the field of education and her longtime support and involvement in alumni activities.

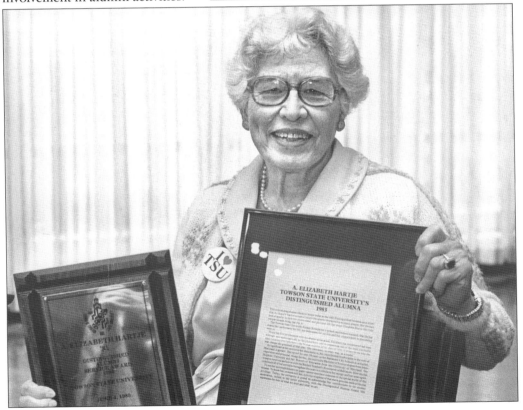

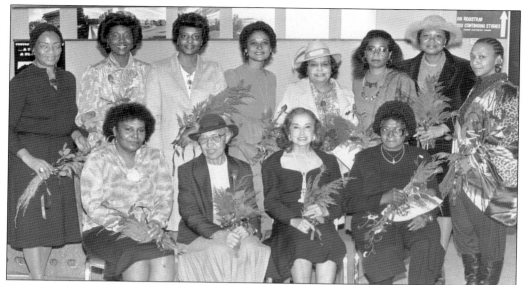

DISTINGUISHED BLACK WOMEN. Towson initiated the first Distinguished Black Women Award in 1983. Shown here are the first recipients. Later this award evolved into the Distinguished Black Marylanders Award, which is given during Black History Month. Pictured here from left to right are (front row) Evelyn Beasley, Enolia McMillan, Louise Young, and Elizabeth Scott; (back row) Hilda Ford, Dr. Cynthia Neverdon-Morton, Alice McGil, Dr. Louis Young, Jaunita Mitchell, Leslie Hammond, Lucille Clifton, and Joyce Scott.

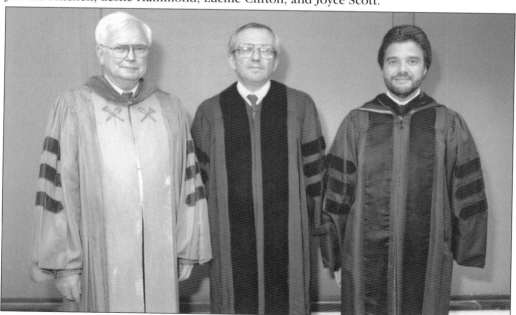

THREE PRESIDENTS. Through its years of rapid growth and expansion, Towson has enjoyed strong leadership. Dr. Joseph Cox (center) began at Towson as a history instructor in 1964, became acting president in 1978–1979, and went on to become chancellor of the University of Oregon System. Dr. Cox received an honorary degree from Towson in 1990 and is shown here with President Smith (left) and future Towson president Robert Caret.

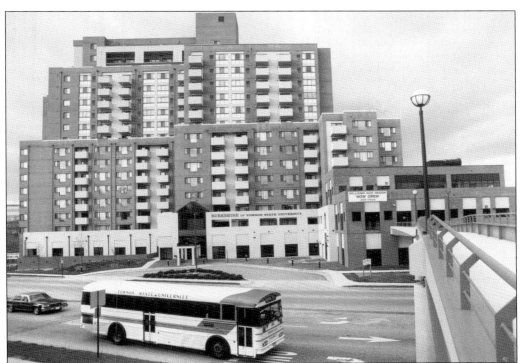

BURKSHIRE. The university improved its facilities when it purchased the 18-story Burkshire Hotel, operated by Marriott Conference Centers. It features 19 meeting rooms for conferences and catered events as well as 135 suites for guests and apartments for students.

AMERICA'S BEST UNIVERSITIES. Beginning in the 1980s, Towson began to appear regularly on *U.S. News & World Report*'s lists of the nation's best academic institutions. It ranked high among regional universities and got high marks for being an efficient and "best value" university.

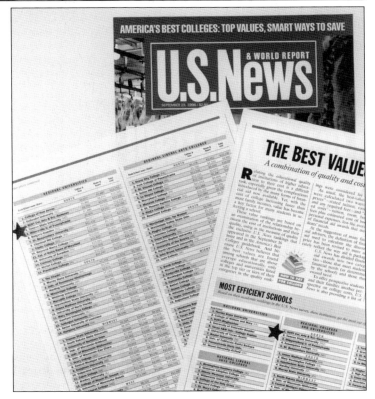

BARBARA HOFFMAN. Graduates of Towson State often found success in business and in politics. Barbara Hoffman (class of 1960), whose mother and daughters were also graduates of Towson, became a long-term member of the Maryland State Senate.

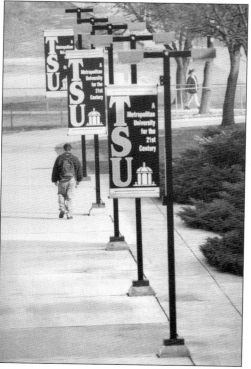

A METROPOLITAN UNIVERSITY. By 1997, Towson State University prepared itself for another name change and the next period of development as a "Metropolitan University for the 21st Century."

Five

TOWSON UNIVERSITY

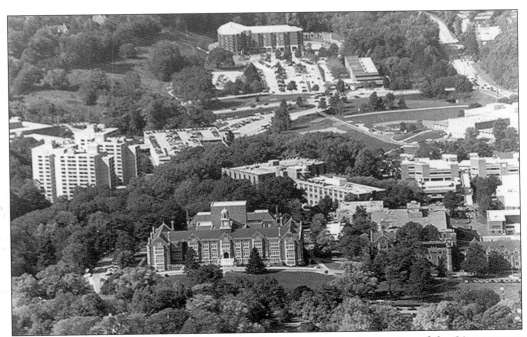

A GROWING PRESENCE. An aerial view shows the campus at the beginning of the 21st century as Towson prepares for a new period of growth and development.

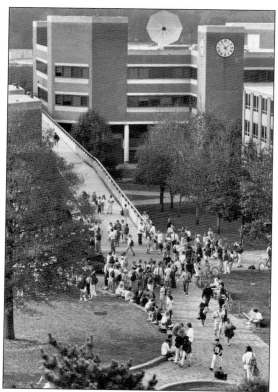

CAMPUS CROSSROADS. Before the campus began its newest phase of growth and construction, the center of campus was where students crossed paths and mingled on "The Beach" in front of Linthicum and the Lecture Hall.

THE LAND OF PLEASANT LEARNING. No matter how much the shape of the campus changed, students still found places to study and socialize outside on beautiful days.

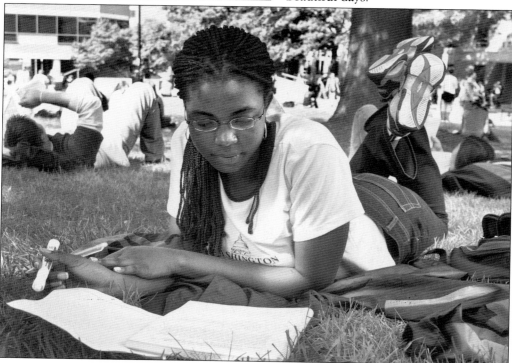

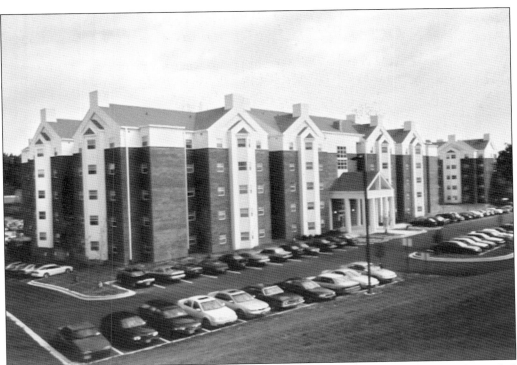

MILLENNIUM HALL. The modern facilities of Millennium Hall were a far cry from the "barracks" that housed students in pre–World War II days.

CONTEMPORARY DORM LIFE. Residence students of the 21st century expected all of the comforts and modern conveniences of home.

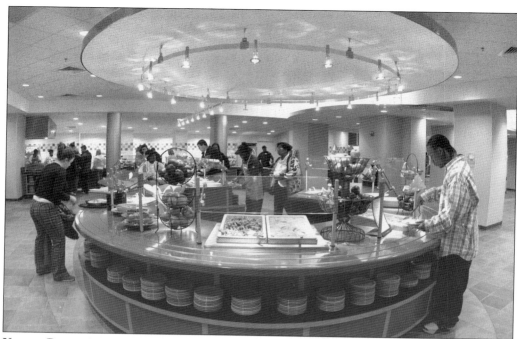

NEWELL DINING HALL. To meet the needs of new generations of students, older facilities were continually updated. The dining facilities in old Newell Hall evolved into a broad selection of eating styles and food choices to satisfy student expectations.

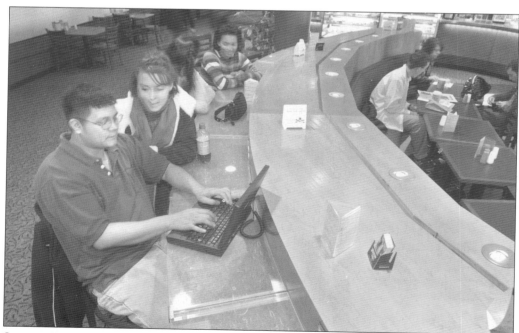

STUDENT LIFE ONLINE. A new cyber café in the University Union and the creation of a "wireless campus" helped students to work and communicate at the time and place of their choice.

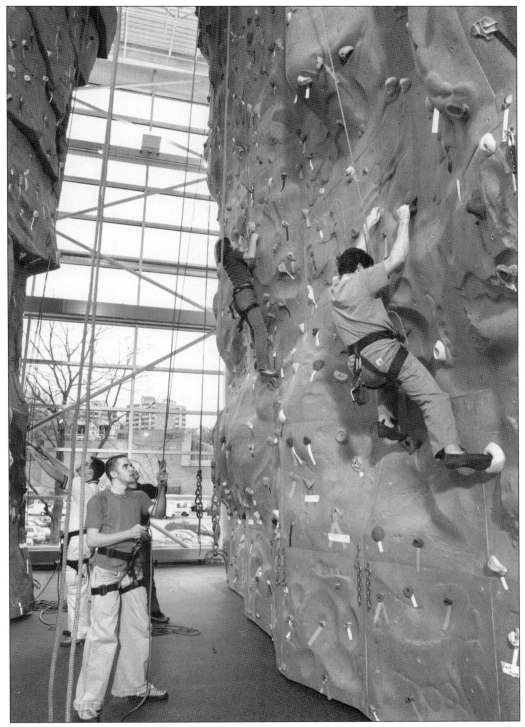

Peregrine's Nest. The phrase, "climbing the walls" took on a new meaning when the university built Peregrine's Nest, a new indoor climbing facility in Burdick Gym.

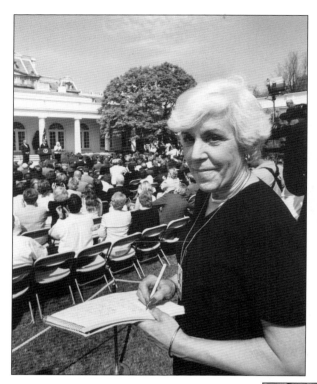

WHITE HOUSE WITNESS. Prof. Martha Kumar, of the political science department, has been Towson's direct link to the White House press corps since the Nixon administration. Described as the world's leading expert on White House press relations, she is often called upon for her knowledge by the reporters. Students who take her course, White House Communications Operations have participated in broadcast interviews with famous reporters like Helen Thomas of UPI (United Press International).

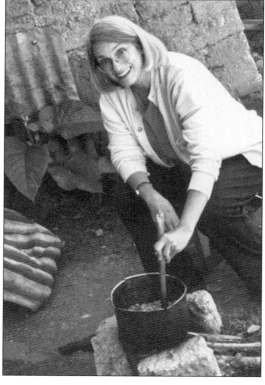

RESEARCH IN BOLIVIAN VILLAGES. Since 1963, anthropology professor Barbara Leons has studied life in two villages of the Yungas region of Bolivia. Her study of communities and traditions in rural Bolivia led her on an unusual academic path as the economic base of the area shifted to growing cocoa plants and the illegal trade in cocaine.

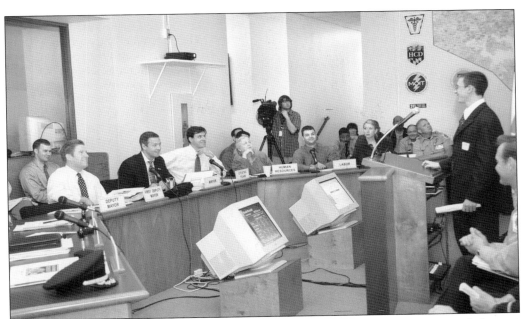

APPLIED MATHEMATICS LABORATORY. When the Baltimore City Fire Department needed to cut costs and become more efficient, they turned to Towson's Applied Mathematics Laboratory for help. Founded in 1980, the lab's students conduct research that helps solve problems for government and industry. Students here are reporting the results to Baltimore City mayor Martin O'Malley (third from the left) and his staff.

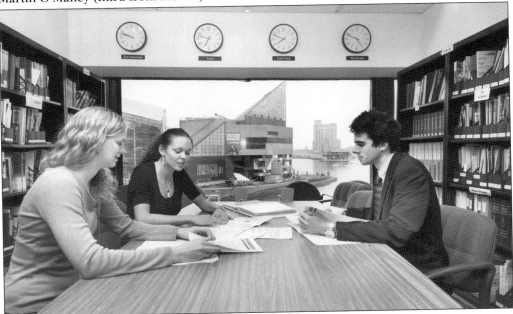

LEARNING BEYOND THE CLASSROOM. With international partners around the globe and a campus in metropolitan Baltimore, Towson's students have the opportunity to learn outside the classroom. Internships, honors classes, study abroad opportunities, and exchanges offer students the chance to enter the job market well prepared.

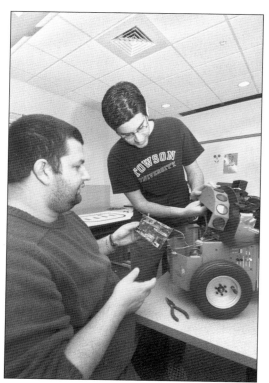

ROBOTICS. Computer and information science majors have the opportunity to work directly with faculty in the robotics laboratory, much like their early predecessors worked with faculty in the teacher training laboratories and classrooms.

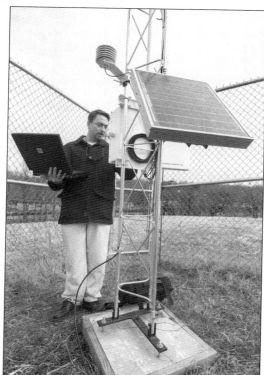

TOWSON WEATHER STATION. A student majoring in geography and environmental planning checks the readings on one of the university's weather stations.

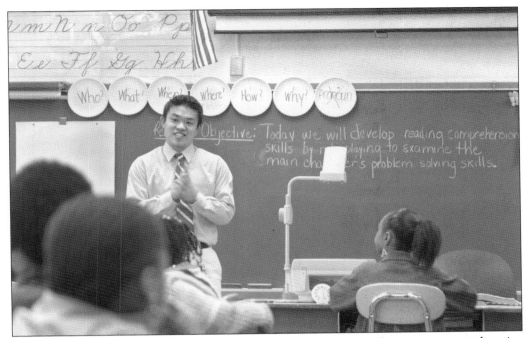

TEACHING MARYLAND'S TEACHERS. Although Towson University has become a comprehensive metropolitan university, it still maintains its excellence in educating Maryland's teachers. Towson remains the largest producer of teachers in the state.

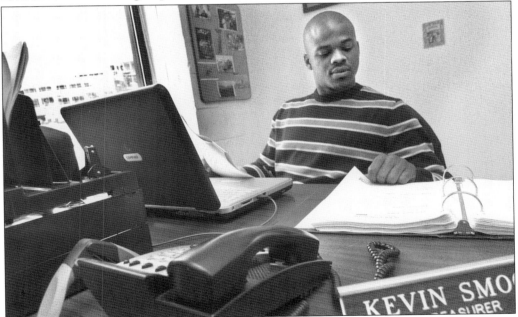

ACCOUNTING FOR SUCCESS. Towson is the only University System of Maryland school with Association to Advance Collegiate Schools of Business international accreditation for both business and accounting. Kevin Smoot, SGA treasurer, student ambassador, and resident assistant, found Towson a good place to "invest in yourself."

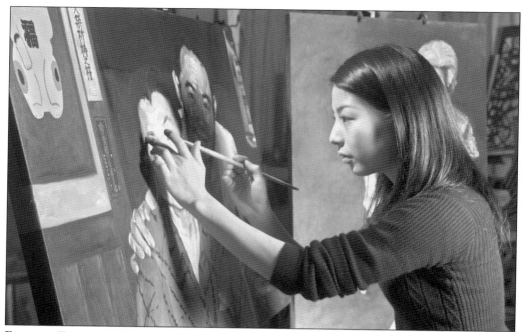

FOCUS ON FINE ARTS. The new Center for the Arts, which reopened after extensive renovation and expansion in 2005, helps Towson retain its reputation in the arts.

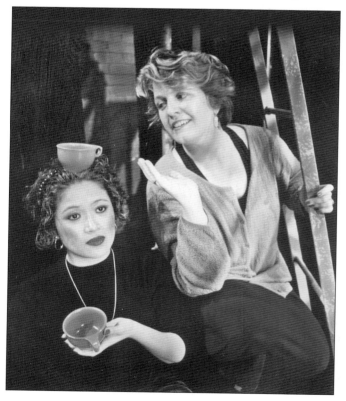

AN INTERNATIONAL FLAVOR. Towson's graduate program in theatre attracts students from around the world and has established new links for the university abroad. Students work with directors and actors from Poland, Japan, and several countries in Africa.

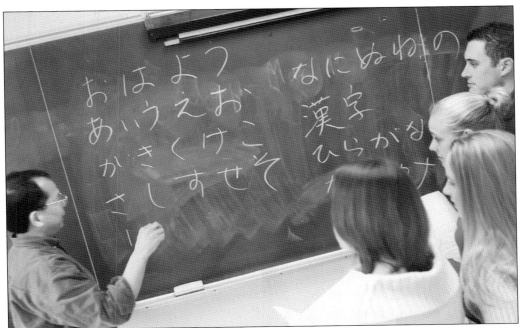

ASIAN LANGUAGES AND CULTURE. Kanji Takeno's Japanese language class helps students prepare for life and work in a world where Asia will play a greater role. Towson's graduate programs in Shanghai and its emphasis on Chinese language and culture are important parts of the new curriculum.

NEW MAJORS. Besides the traditional arts and sciences, as well as teacher training, Towson's curriculum includes many new majors in professional and applied fields. Here students in the physician's assistant program learn to give injections using an artificial arm.

111

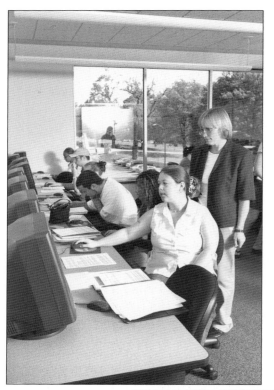

INFORMATION TECHNOLOGY. New majors in different aspects of computer and information sciences, or in homeland and computer security, help students find careers in a rapidly changing job market. The Center for Applied Information Technology has the largest number of graduate students in the Baltimore area and also offers customized programs for local businesses and industries.

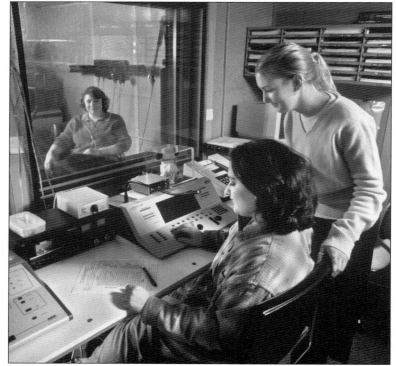

NEW DOCTORAL PROGRAMS. In 2001, Towson entered a new era in its historical evolution by offering its first doctoral programs. Programs in audiology and occupational sciences were the first to offer a doctorate, followed by education and others shortly after.

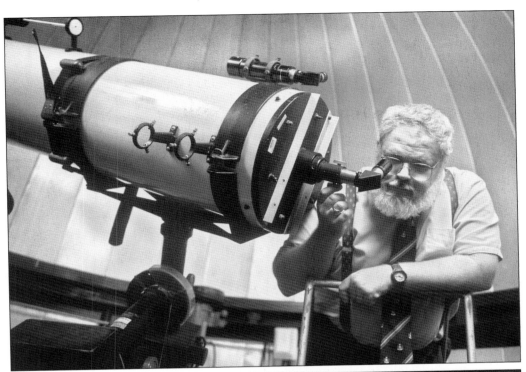

STARGAZERS. For more than 30 years, Towson's Watson-King Planetarium has served the research needs of the faculty as well as the basic education needs of the community. In 2001, Dr. Alex Storrs used the telescope to discover a companion to Asteroid 107 Camilla, only the fifth companion asteroid ever found.

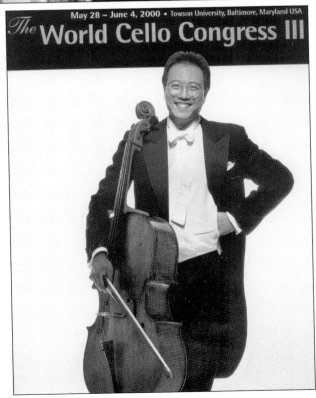

May 28 – June 4, 2000 • Towson University, Baltimore, Maryland USA

The World Cello Congress III

WORLD CELLO CONGRESS III. Towson hosted the World Cello Congress on its campus in 2000. Yo-Yo Ma and other noted cellists performed for large audiences and taught students in master classes.

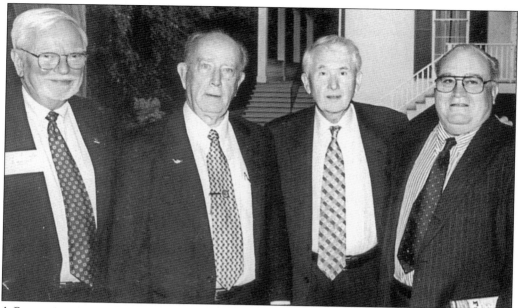

A COMMUNITY AND CULTURAL LEADER. Towson's location in the northern suburbs of metropolitan Baltimore has made it attractive for cultural and community events. The university hosted Pulitzer Prize–winning author Frank McCourt (*Angela's Ashes*) in 2001. President Smith; former governor and Maryland comptroller William Donald Schaefer (second from the left) and Gene Raynor joined the author (second from the right).

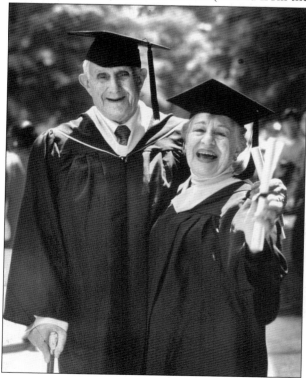

TOWSON'S "SENIOR" STUDENTS. At ages 81 and 79, Irv and Sylvia Cohen are the oldest couple to graduate from Towson. They returned to school after retirement and completed their degrees through the Golden ID program. Graduating in May 1998, Irv received his degree in political science and Sylvia received her degree in theatre.

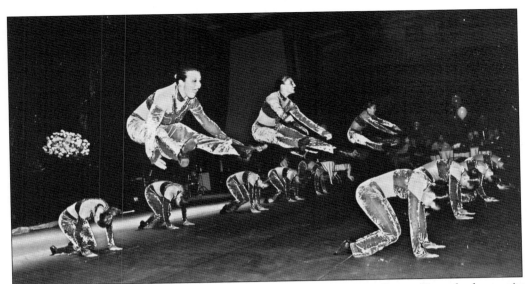

NATIONAL CHAMPIONS. By 2005, the 21-member Towson University Dance Team had won six straight National Cheerleaders Association Collegiate titles. The Division I troupe, coached by theatre department faculty member Tom Cascella, was also a multiple winner of the Grand National Championship.

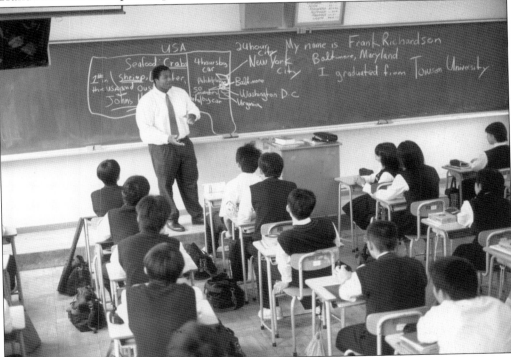

BIG MAN IN JAPAN. At 6-foot-3-inches and 265 pounds, Frank Richardson (class of 1998) stood out in the classrooms at Matsuyama Chou High School, where he taught English for a year. A former TU football player and president of the Student Government Association, Frank was a popular teacher among the Japanese teenagers.

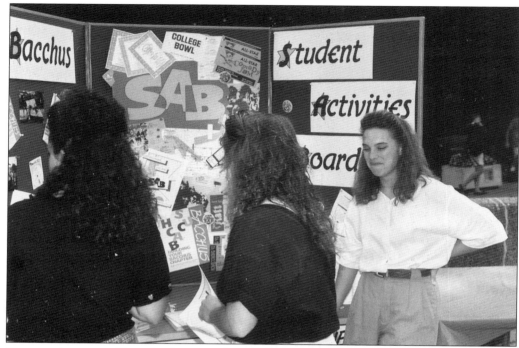

STUDENT ACTIVITIES FAIR. Students can learn about the various organizations and clubs on campus each autumn at the Student Activities Fair.

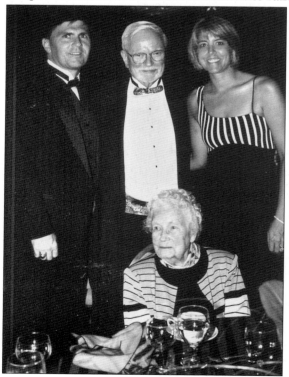

HOKE SMITH RETIRES. For 22 years, Hoke Smith led the development of Towson into a metropolitan university. He reorganized the university into 8 colleges, added 42 new programs, expanded the graduate school, established doctoral programs, enhanced international enrollment, and multiplied the university's endowment. At the gala celebrating Dr. Smith's retirement, he (standing center) is congratulated by his mother, Bernice (seated), and by Congressman (later governor) Robert Ehrlich and his wife, Kendall.

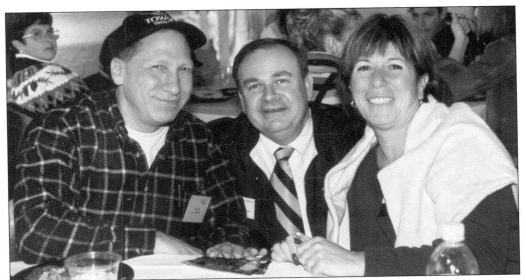

MARK PERKINS. Following Dr. Smith, Mark L. Perkins, president 2001–2002, brought a new perspective to the campus. A native of Richmond, Virginia, he earned a doctorate in psychometrics and statistics from the University of Georgia. Prior to coming to Towson, he was chancellor of the University of Wisconsin–Green Bay. He resigned in April 2002. Perkins (center) is shown sharing a moment with parents Alan and Michele Feder during Family Weekend.

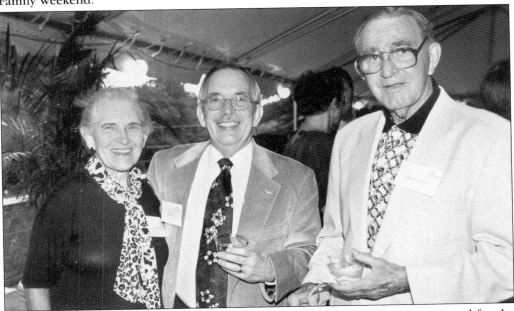

DAN JONES. During the search for a new president, a longtime administrator and faculty member, Dan Jones, stepped in as interim president in 2002–2003. Dr. Jones came to Towson in 1966 as an English instructor, served two decades as department chair, then served as acting dean of the College of Liberal Arts and acting provost before leading the university as interim president. Alberta Eidman, Dan Jones, and Harvey Eidman (pictured here from left to right) enjoy the 2002 Maryland Arts Festival.

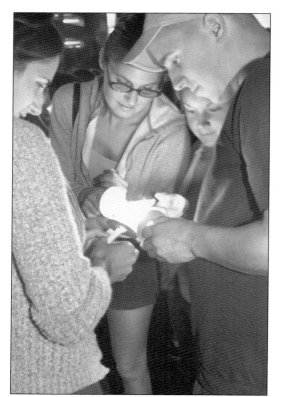

THE UNIVERSITY MOURNS 9/11. Shown here, students gathered to mourn the victims of September 11, 2001. Four members of the Towson University family were among those lost: Patricia Cushing, Cortz Gnee, Joseph Maggitti, and Honor Elizabeth Wainio (class of 1995).

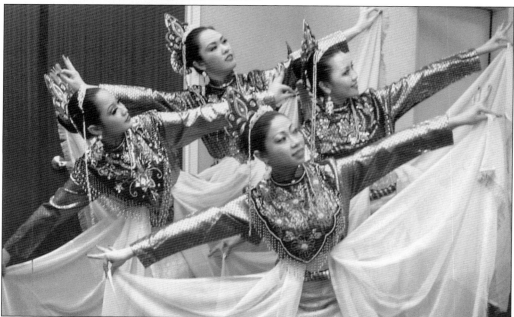

MANY MOONS DANCERS. Each fall, the Asian Arts and Culture Center invites students and community members to celebrate the Many Moons Festival by enjoying art exhibits and performances by dancers and musicians from Asia.

JOHN B. SCHUERHOLZ PARK. Returning to his alma mater in 2001, John Schuerholz (class of 1962) dedicated the new baseball stadium named in his honor. As one of the top executives in major-league baseball, Schuerholz, executive vice president and general manager of the Atlanta Braves, led the effort to renovate the field and construct a new baseball stadium.

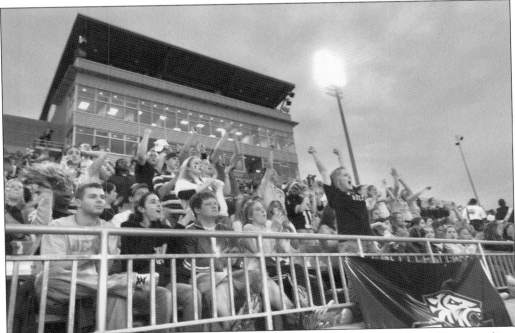

NEW STADIUM. In 2003, Towson completed the renovation and expansion of its athletic stadium for football, lacrosse, soccer, and track and field. Seating 11,000 fans, it was the newest and largest college facility in the Baltimore region.

Bob is Back. On July 1, 2003, Towson University welcomed back Robert L. Caret as its 12th president. Prior to Dr. Caret's eight-year presidency at San Jose State University, he had a long career at Towson. He began at Towson State College as a visiting assistant professor of chemistry in 1974, rose to become acting dean, then dean of the College of Natural and Mathematical Sciences from 1981 to 1987, and was appointed provost and executive vice president for academic affairs between 1987 and 1995.

TU CAMPUS GOES WIRELESS. In February 2005, President Caret symbolically cut the cord of wired technology and introduced the campus to "Towson Unplugged." The $3.2 million wireless network allows students, faculty, and staff to connect to the Internet from anywhere on campus.

ALUMNI CRAB FEAST. By 2006, Towson's alumni numbered over 100,000. Here members of the Atlanta Alumni Chapter enjoy a Maryland-style crab feast.

TIGERFEST. Students find a release for their spring fever at Tigerfest, which replaced the genteel ways of the May Day celebration. In early May, bands, games, and great food attract not only Towson students but also the community to this event.

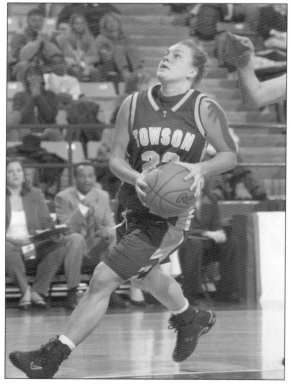

A TIGER ON THE COURT. Kelli Talbot (class of 2005) was a four-year starter for the Tigers and led the team to a fourth-place finish in the Colonial Athletic Association in her senior year. She was also the winner of the CAA's prestigious Dean Ehlers Leadership Award.

TIGER MASCOT. Although the historical records are not clear, sometime in the late 1950s, Towson's athletic teams ceased to be called the "Knights" and adopted the tiger as their mascot. By 1963, the Tiger was officially approved by the SGA and accepted by the student body. Lou Winkleman (class of 1964) was the first to wear the mascot's stripes. The Tiger's appearance evolved over the last four decades to our current version, "Doc."

JAMES C. "CHIP" DI PAULA, JR. (CLASS OF 1986). "Chip" Di Paula (right) is currently chief of staff to Gov. Robert Ehrlich. He was previously secretary of the Maryland Department of Budget and Management. At 40, he was the youngest person in Maryland history to hold that position. President Caret congratulates him on receiving the 2004 Distinguished Alumni Award.

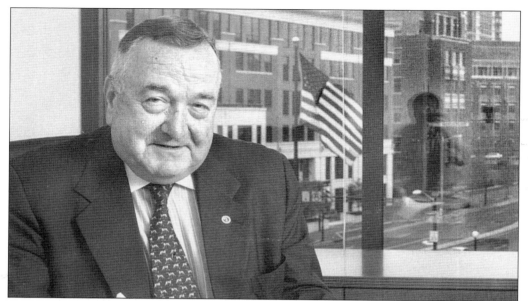

ED BADOLATO (CLASS OF 1960). As Towson moved beyond its teachers college roots, its graduates achieved success in new fields. Ed Badolato became an expert on homeland security and terrorism and served as deputy assistant secretary at the Department of Energy under Presidents Ronald Reagan and George H. W. Bush. Badolato became the principal architect of the government's nuclear weapons security programs.

BARRY LEVINSON. In September 2003, Towson University honored Baltimore film and TV director Barry Levinson with its Distinguished Lifetime Achievement Award. Winner of the Oscar for directing *Rain Man* and an Emmy for *Homicide*, Levinson featured his hometown in films like *Diner*, *Tin Men*, *Avalon*, and *Liberty Heights*. Levinson taught several master classes at Towson and then celebrated with a reception at Towson and a special showing of *Diner* at the Senator Theater.

$10.2 MILLION GIFT FOR THE SCIENCES.
In 2005, the Robert M. Fisher Memorial Foundation gave $10.2 million to Towson for support of the sciences and mathematics. Jess Fisher attended MSNS in the 1930s and together with his wife, Mildred, established the foundation in honor of their late son, Robert. The largest gift in Towson's history will create an endowed chair, set up scholarships in science, mathematics, and pre-engineering, and enhance the college's endowment. The college was re-named the Jess and Mildred Fisher College of Science and Mathematics.

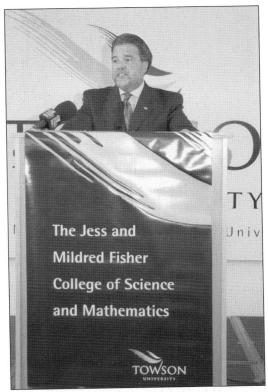

GOV. ROBERT EHRLICH. Since 1995, Robert Ehrlich, first as congressman, then as governor, made frequent visits to Towson to talk to classes on persuasion. When he became governor of Maryland, he donated his congressional papers to Towson University.

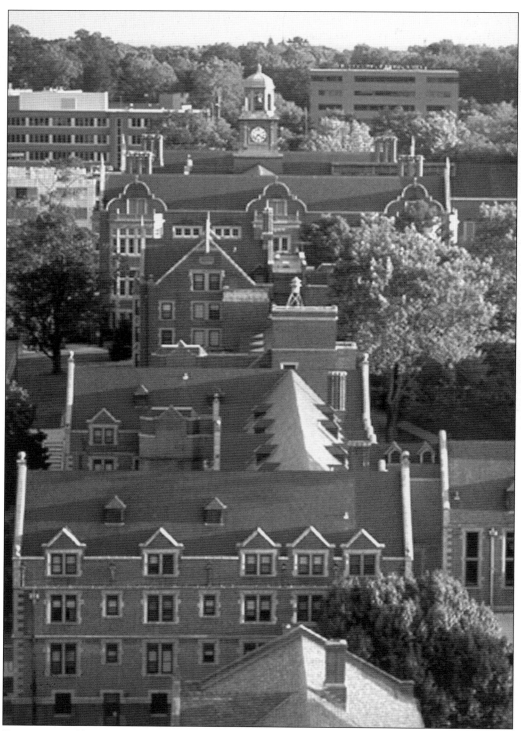

ROOFTOPS OF TOWSON UNIVERSITY. The rooftops of Towson University provide a unique view of the campus landscape.

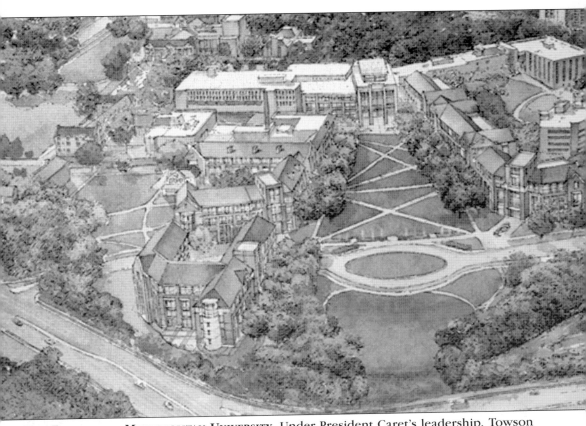

New Plans for a Metropolitan University. Under President Caret's leadership, Towson moved quickly to adopt a new master plan for renovating and expanding the campus and to establish a strategic plan to carry the university through 2010.

SOURCES

Murfin, Steve. *The Perfect Season: A Story about the Undefeated 1974 Towson State College Football Team.* Timonium, MD: Corporate Printing Solutions, 2004.

State Teachers College at Towson Alumni Association. *Seventy-five Years of Teacher Education.* Towson, MD: The Alumni Association, 1941.

PHOTOGRAPH CREDITS

The majority of the photographs were taken from the University Archives, Design and Publications, and Photographic Services of Towson University.

ADDITIONAL PHOTOGRAPHIC SOURCES:

"The Cottage": William C. Kenney
"Grub Street": Melissa Malanowski and Kristin Ramsburg
"Perfect Season": Kathy Dudek and Steve Murfin